APERTURE

NUMBER ONE HUNDRED
FALL 1985

Aperture, a division of Silver Mountain Foundation, Inc., publishes *Aperture* at New York, New York 12546. Officers are Chairman of the Board Shirley C. Burden; President Arthur M. Bullowa; Executive Vice President Robert A. Hauslohner; Executive Director Michael E. Hoffman; Treasurer Robert Connor; Secretary Robert Anthoine. Directors are Robert Anthoine, Arthur M. Bullowa, Shirley C. Burden, Stanley Cohen, Robert Coles, Alan Fern, Richard A. Freling, Robert A. Hauslohner, Michael E. Hoffman, Naomi Rosenblum, Evan H. Turner. Minor White: Editor 1952–1975.

Executive Director, Michael E. Hoffman; Vice President, Publishing, Christopher Hudson; Editor, Mark Holborn; Managing Editor, Lawrence Frascella; Production Consultant, Steve Baron; Production Associate, Katherine Houck; Designer, Wendy Byrne; Editorial Assistant, Thomas Blum; Work Scholar, Harris Fogel; Circulation Manager, Mary Bilquin. Contributing Editors: Robert Coles, R. H. Cravens, Lloyd Fonvielle, James Baker Hall, Ben Maddow, Anita Ventura Mozley, William Parker, Jed Perl, Joel Snyder, Jonathan Williams.

Front Cover: David Graham, *Marge Gapp's Studio*, Philadelphia, Pennsylvania, 1979
Inside Front Cover: Sarah Charlesworth, *Rider*, 1984
Page 1: Edward Weston, *MGM Studios*, Culver City, California, 1939

Composition by David E. Seham Assoc., Inc., Metuchen, New Jersey. Printed and bound in Italy by Amilcare Pizzi, S.p.A, Milan.

Aperture (ISSN 0003-6420) is published quarterly, in February, May, August, and November, at Elm Street, Millerton, New York 12546. A subscription for four issues is $36. Second Class Postage is paid at Millerton, New York 12546. Postmaster: send address changes to Aperture, Elm Street, Millerton, New York 12546. A subscription for four issues outside the United States is $40. Because no publication of fine photography can be self-supporting in America, it is hoped that sponsors who wish to help maintain a vital force in photography will become Patrons ($1000), Donors ($500), Friends ($250), Sustaining Subscribers ($150), or Retaining Subscribers ($75). Names of Patrons, Donors, Friends, and Sustaining and Retaining Subscribers will appear in every issue for the duration of their sponsorship. Gifts (the donation less $36 for the subscription to *Aperture*) are tax deductible. Single copies may be purchased for $12.50.

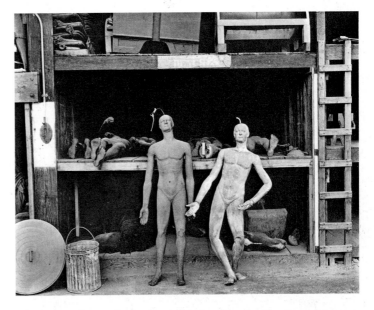

Photographs and photopieces by Sarah Charlesworth, Laurie Simmons, Richard Prince, Robert Cumming, Hiroshi Sugimoto, Lejaren à Hiller, John Baldessari, Nic Nicosia, David Graham, Joel-Peter Witkin, Clarence John Laughlin

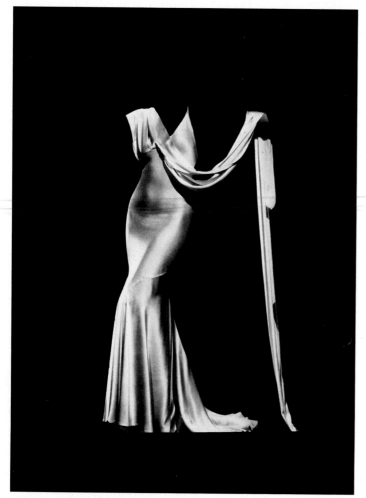

SARAH CHARLESWORTH, Figure, 1983 (original print 30x40).
Photopiece derived from the film *Desire* (1936) with Marlene
Dietrich, directed by Frank Borzage.

The Edge of Illusion

THE 100TH ISSUE OF *APERTURE* provides a sense of the
future and measures the changes in the practice and under-
standing of photography. The first issue of *Aperture* was pub-
lished by Minor White in San Francisco in 1952. The editorial,
signed by the founders, Minor White, Dorothea Lange, Nancy
Newhall, Ansel Adams, Beaumont Newhall, Barbara Morgan,
Ernest Louis, Melton Ferris, and Dody Warren, offered the pe-
riodical as a creative catalyst to photographers everywhere. The
spirit of *Aperture* was one of exploration, endorsed in the title
"Exploratory Camera" used in the first issue by Minor White.
In the following issue Dorothea Lange wrote, "Photography
today appears to be in a state of flight," referring to the intro-
duction of color as a photographic value, the dimensions of the
motion picture, and the technical advances of science—chal-
lenges that are as great today as they were thirty-three years
ago. The 100th issue reiterates the original intentions of
Aperture. A catalyst is offered.

Alfred Stieglitz, the father of modern American photography,
believed that innovation was born out of tradition. He trans-
formed the possibilities of photography from an objective,
documentary science, in which the world was composed of re-
cordable details, and from the pretensions of an aesthetic that
imitated a painter's perspective and surface. He invested his art
with the qualities of equivalence, elevating the photograph be-
yond the details that constituted its surface. Minor White in
turn embraced Stieglitz's sense of the equivalent, advancing the
idea of photograph as metaphor.

The representational, descriptive intentions of so much 19th-
century photography, and the modernism and symbolism of
Stieglitz's equivalence, remain permanent qualities of the pho-
tographic tradition. In 1985, that tradition is challenged not
only by photographers but by those artists whose work is de-
rived from photographic practice. They provide profound com-
ment on the nature of photographic evidence. The publication
of the 100th issue is the most appropriate occasion to explore
the challenges of this work. Representation and metaphor have
been displaced by a code of illusion. The future to which this
issue points is an ambiguous world where creative exploration
incorporates advertising and fashion imagery and artists like
Richard Prince and Sarah Charlesworth respond to the over-
abundance of photographic images, associations, and assump-
tions that have accumulated in the last decades. A cinematic or
a television reality replaces unmediated perception, and history
becomes a fiction.

In response to Edward Weston's retrospective exhibition at
the Museum of Modern Art in 1946, Clement Greenberg, in
an otherwise hostile review, claimed that the two frontal views
of "ghost sets" in a movie studio were among Weston's finest
photographs; Ben Maddow, Weston's biographer, felt that they
were vulgar and anecdotal. The ambiguity of these "ghost sets,"
unlike the great majority of Weston's photographs, would be
in perfect accord with current sensibility. Weston's film dummies
photographed at MGM studios in 1939 form a direct link to
Laurie Simmons's mannequin drama, represented here with
"real" models photographed in showroom poses. Sherrie Le-
vine's strategy of re-presenting artistic icons, including work
by Edward Weston, as her own has placed a question mark on
the authenticity of the image, which haunts this issue. No
prophecy of the future is suggested. The sanctity of the pho-
tographic print is overturned, exposing a tradition from which
so much of this work appears divorced. Yet the nature of the
question is to doubt the appearance, discard the "real," and
perhaps discover a little more about the illusions behind the
conventions we have nurtured.

THE EDITORS

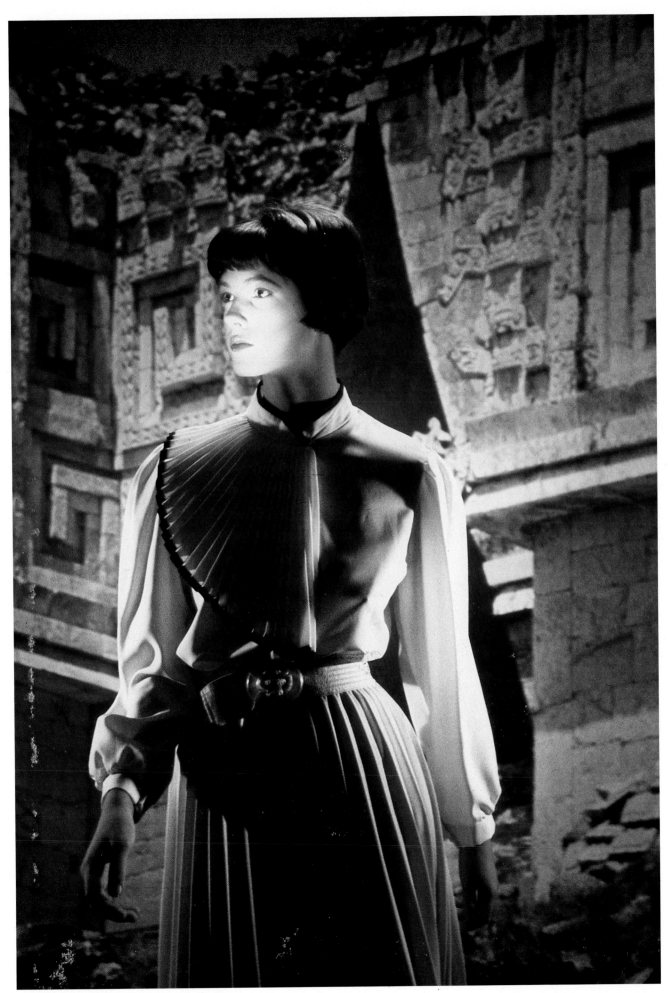

LAURIE SIMMONS, Aztec Crevice, 1984

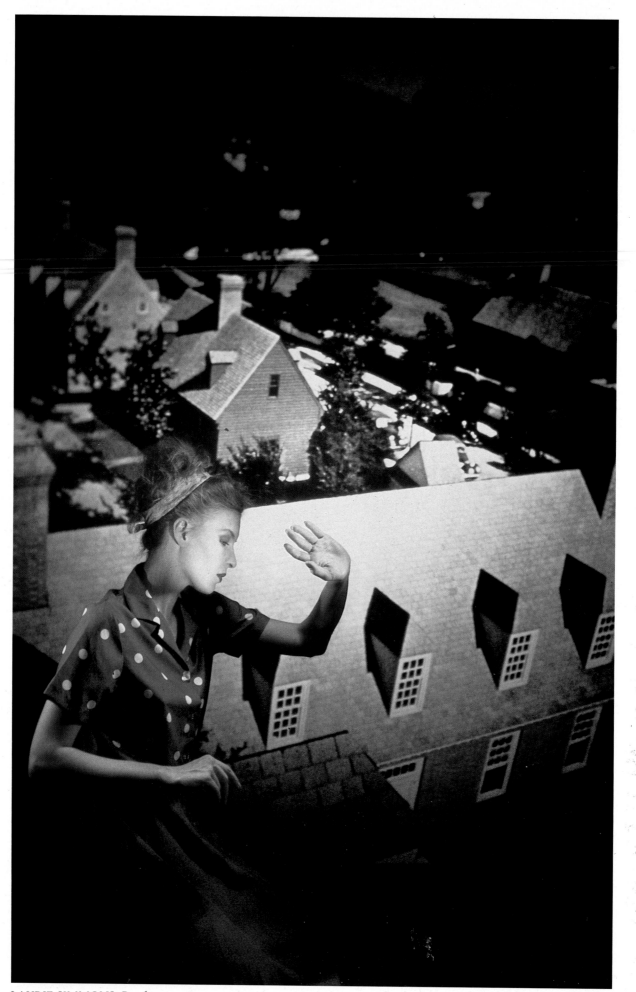

LAURIE SIMMONS, Rooftops, 1984

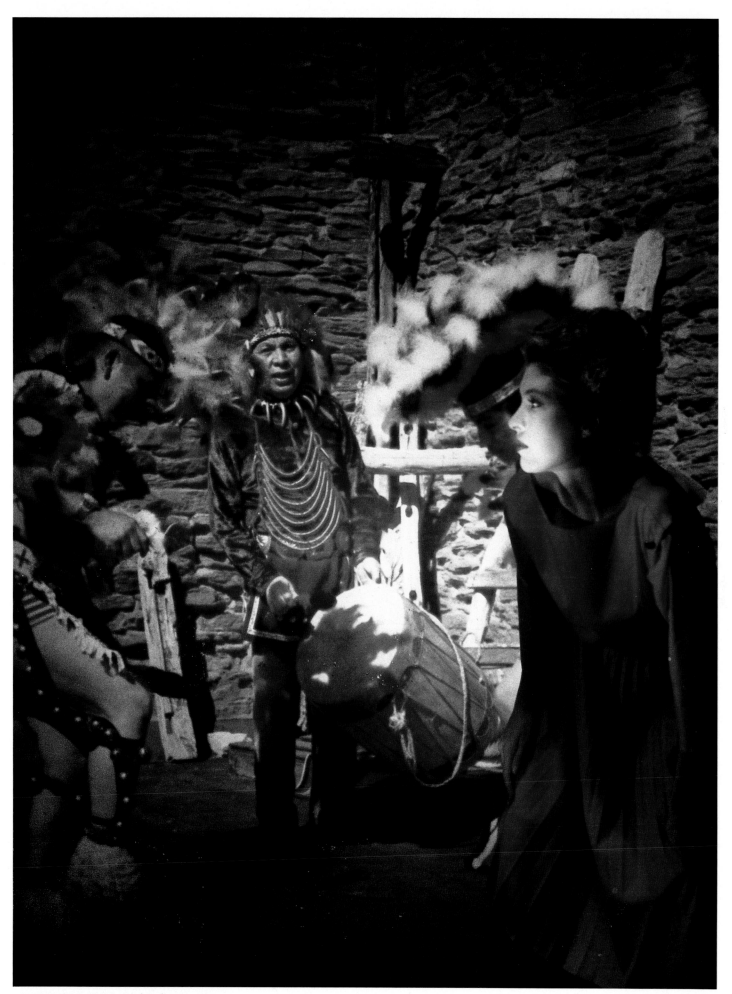

LAURIE SIMMONS, Red Indians, 1984

 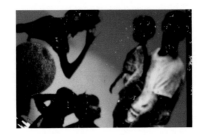 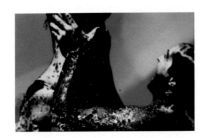

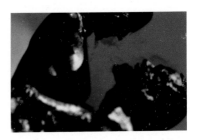 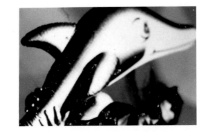

RICHARD PRINCE, Untitled (Sunsets), 1981

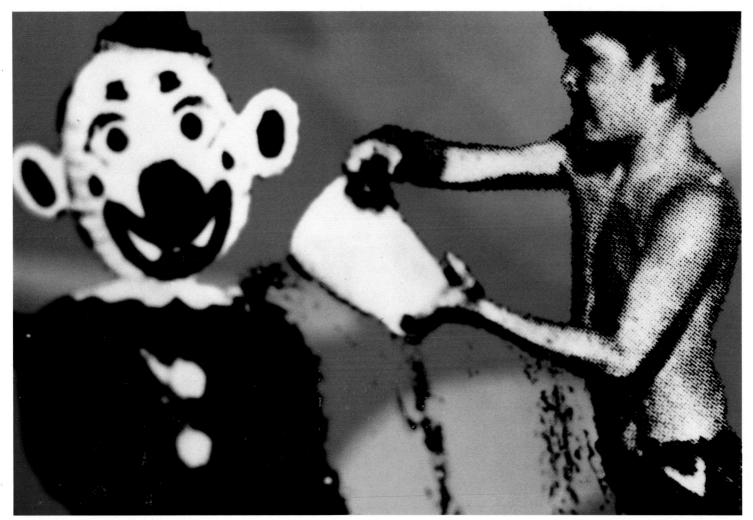

RICHARD PRINCE, # 3 Untitled (Sunsets), 1981

Richard Prince

An Interview by David Robbins

Richard Prince initiated rephotography in New York in 1977. Simply expressed, rephotography is photographing existing images and it is an activity that since its invention has been frequently cited as among the most compelling evidence of a genuinely postmodern phase of visual art. Richard Prince is also the author of a novel, Why I Go to the Movies Alone, *which elucidates many of his attitudes toward images and their role as social mediators.—Ed.*

DR: We've become proficient at interpreting the subtle subtexts of mass-culture images, like a generation of social phrenologists, so much so that whereas Godard used to speak in the '60s of his films being concerned with "the children of Marx and Coca-Cola," the popularization of semiotics in the '70s and '80s has spawned a generation we might aptly term "the children of Barthes and Coca-Cola."

A lot of the critical support your work has received has been for its alleged "deconstruction of the advertising image." Do you see your work as being engaged with this?

RP: To some extent I'm interested in what we produce and what we consume. What we think we own and what we think

we control. Do we own and control our TV sets, that kind of thing. I'm interested in the assumptions we make in relation to those interests. I have read where my work is a deconstruction of the advertised image. Well, that's an extremely narrow reading of the work, if you ask me. Madison Avenue's decisions don't particularly interest me. My work is not about illustration, allegory, irony. I'm interested in what some of these images (that happen to appear in the advertising sections of magazines) *imagine.* I like the presumptuousness and the shame usually associated with these images. I like how unbelievable these images appear to be. How psychologically hopped-up a *watch* can look! I've never felt threatened by these images and certainly never felt compelled to buy what's represented in the advertisements. Sometimes, *most of the time*, what's represented is just wishful thinking. I'm interested in wishful thinking.

DR: How do you locate your images?

RP: My art supply store is a magazine store. I look at magazines in stores, in friend's houses, on planes. . . . I just went to Burbank, California. They have one of the biggest magazine stores in the world. Sometimes it takes a long time to give my pictures the that's-the-way-they're-supposed-to-look look. You have to

RICHARD PRINCE, Lisa, 1985

look at a lot of magazines to find four images, for example, that appear to be normal and work together.

DR: I like your work because it zooms in on the dreamy unrealities that are constantly directed toward us by television, the movies, advertising, magazines: the public fictions in which we are steeped, images that other people want us to consume. If I turn on my TV, I get hundreds of "personalities" floating toward me, and it's hard after 25 years of viewing to know where they stop and I start. Surely most art just adds more fiction—personal fictions—without in any way clarifying our relationship to such images.

RP: Sometimes I think all my work got sent away for. You know, like I saved up my box tops, sent them off to Battle Creek, Michigan, and this is what I got back in the mail. "Baking soda makes the submarine go under water and propels it!" But I'm not just making another fiction. That wouldn't interest me at all. I'm interested in the fiction becoming true. You know what I mean?: it wouldn't surprise me if the day came when the earth really *did* stand still. I'm interested in the idea of making nonfiction art. In other words, I'm interested in making a fiction look true. It seems to me that trying to present something believable might be about *asking too much*. I'm interested in my photographs asking too much.

DR: Certainly the fictions are out there, thriving away. But how does one go about making nonfiction art?

RP: The fact that my pictures already exist in public helps to establish their reality. I obviously don't make the images up. My style is hopefully a *convincing* style. Rephotography is photographing what's already been determined, so obviously rephotography is about *overdetermination*. Basically, I'm not interested in impressions, and I like to think I'm in the habit of telling the truth. I always liked the TV shows "To Tell the Truth," "Truth or Consequences," and "Who Do You Trust?": "Okay, panelists, let's turn all the cards over."

DR: The speculative image has been central to the art of this century: the artist's *feelings* about a given image as the image. But you are disinclined to operate this way. Why are you so suspicious of the speculative?

RP: This is the scenario: The "Perry Mason Show," right?, and I have to appear before the court. The court doesn't admit impressions or an *expression* about something. The judge says, "Okay, mister, what makes your picture so real? Back it up!" The jury pipes up and says, "We already have our own nightmares and dreams, we don't need yours . . . we don't want what's *you*, ya schmuck. What have you been doing all your life, living in the Black Forest in a castle? What do you think you are, *special*? Show us evidence!" Perry Mason throws my photographs on the mercy of the court, and the court takes one look at them and lets me off scot-free. My family breaks down and cries. Reporters shake my hand and take my picture. And I get a proposal for marriage three days later from one of the members of the jury. How do you like it? I'm going to call it *I'm So Excited*. Simply put, I'm not interested in people having to take my word for anything.

DR: Your work departs from much of what came before it—and is distinct certainly from all expressionisms—in that it is not based on the objective correlative. That is, the traditional artist manipulates inanimate material of one kind or another *to communicate an experience he/she has already had*, or *to re-create in the viewer an experience the viewer has already had*. That's something that's always bothered me about art, that fundamentally nostalgic impulse. The wish for childhood, the curatorial wish. Such work may *look* really wild, may be all frothy and rabid with paint, but with such work our understanding of the nature of art stays just where it "belongs," it doesn't question either its social position or psychological use.

In contradistinction, your work doesn't seem to be about recreating an experience the viewer has already had.

RP: Or that *I've* already had. I tend to take pictures that I've never seen, pictured, or observed in my own day-to-day routine. I like to try to figure out where I fit in, my relation to an image that I have no memory of. Just what *is* part of my experience? My relationship turns out to be more about my personality than my personal feelings or experiences. You know, sometimes I think I wouldn't even dream of the pictures I take.

DR: Right, pop memory: is it Ella or is it Memorex and what the hell has either to do with me?

RP: Yes. So it is a species of discovery, surely, but it is not a rediscovery. It's not nostalgia, even if the pictures can be associated with particular pop histories. I have something to do with that picture, personally, because of that picture's personality, because of my personality—I wouldn't want to say otherwise. But it's not a personal reaction. I'm not kneejerking against the picture. I'm not trying to put any kind of distance between myself and the subject matter. On the contrary: I'm trying to get as close to that picture as possible.

DR: The art historian Svetlana Alpers writes about 17th-century Dutch painting in a similar way. She says that the Dutch "sidestep the issue of style or manner almost completely to put *nature seen* before personal style or self. . . ."

RP: I like to take an unbelievable picture and present it as normally as possible. I like to present it with a sensation of normalcy. I like to think of normality as the next special effect.

DR: How did you arrive at the decision to rephotograph magazine reproductions?

RP: Well, certain social facts helped to point the way. The '60s had created an atmosphere whereby the manipulation and control of consumption, of the flow of products and images, became quite accessible, quite understandable by the average guy. I always liked the *promises* that went along with some of these products. You know, like "Relief in just two hours." The awakening of desire. These authorless images are very good at living it up. I mean, I wouldn't even mind being relieved *for* two hours.

DR: And on top of the '60s came the one-two punch of Vietnam/Watergate, which really rattled people's belief in the authority of institutions—what intellectuals refer to as the "crisis of legitimation."

RP: Yeah, and in this instance, the result of that sweeping skepticism was, for me, to stop getting my information from history. What's been presented as "history" of course has turned out to be the real fiction.

DR: The official fiction. Something like the Westmoreland suit against CBS really highlights this. The deinstitutionalization, if we can use the word, of history is a pretty unsettling realization, from which we've seen half the nation freak out and seek an antidote in the nostalgia trip of Reagan. In any case, a different breed of art was bound to emerge from these social explosions.

RP: Personally, I started practicing without a license. Not waiting for permission. I don't want to trivialize this realization. It takes a certain ability to perceive the fictiveness of history, and to proceed from there. To just decide one day, History is Fiction—it wasn't really that it was a shock, because it certainly makes sense, but once you realize it you have to come to terms with it, and begin to see the degree to which things have to do with representation. The tough part is, a lot of the time, you're on your own.

DR: When you began rephotographing in the late '70s, was it clear to you that your particular use of the camera—as a selector of already created images—paralleled another significant cultural change: namely, the tremendous increase in the unauthorized reproduction of music? A lot of music got transmitted and wound up in people's homes via cassettes, taping off the radio. The proliferation of New Wave and experimental music in the late '70s, with the attendant tiny independent labels, drew people's interest away from the corporate rock that had dominated the decade. It was the decentralizing of culture. I bring this up to show that ideas about "property" were in the air, as aestheticized politics.

RP: I think the term at that time was "pirating." It was a business term. To me it was just stealing. "Appropriation" was a more sanitized version of the word. I'm interested when something offensive becomes respected. Taken for granted. I'm interested in being taken for granted. You know, marrying the sheriff's daughter.

DR: How does one come to the decision to put a photograph or reproduction—in your case a magazine reproduction—in front of a camera? And how does one make the break whereby one goes from tearing the picture out of a magazine and pasting it so there was still an element of collage, to literally sticking the picture in front of the camera, photographing the picture, and presenting the result as a real photograph?

RP: Frankly, part of what drew me to the idea of rephotography was the fact that I'd never really liked my work. I'd sold paintings since the early '70s, had solo shows, was successful. But I never liked my work. Ever. Because I did it. Obviously, if you don't like your work, a logical alternative is to take someone else's—and call it yours. The activity of taking seemed reasonable. I started to think of the camera as a pair of electronic scissors. The public images I would take didn't really need anything done to them. They didn't need to be silkscreened or painted on or collaged. The photograph that I presented had

to resemble, as much as possible, the photograph that had initially attracted me. It was a matter of being as presumptuous as the original picture. I was interested in the camera as a technological device rather than as a mechanical one. I'm interested in sitting at my desk with my hands folded neatly in my lap.

My notion of rephotography came about because I didn't want to aestheticize the picture and I didn't want to deal with collage. I didn't want to deal with a seam because, in fact, I wanted my picture to be believed by the audience.

DR: The seamless real.

RP: It's another ingredient that helps to suspend the disbelief that normally accompanies the viewing of unbelievable pictures. As far as I'm concerned, Freud was Montgomery Clift.

DR: What's it feel like when you look through the camera at a two-dimensional image, essentially a "landscape"?

RP: It's strange. It's as if I can suddenly distinguish between its manifest content and its latent content. It's like the picture starts to behave simply because I'm looking at it.

DR: Much of what you've said points to a major shift in the conception of the camera. The modernist conception of the camera was at base a belief that the camera by its nature told the truth: the nature of the device, mechanically, was such that it was obligated to record accurately that which occurred before its lens. It's essentially a passive conception, with Warhol as the apotheosis of this presupposition. But by the beginning of the '70s, artists knew there was no particular reason to believe in the institutionalized truthtelling characteristics attributed to the camera: all other "governing bodies" were cast in doubtful light, and the camera's reportorial abilities came to be included. So, in the work of people like Robert Cumming and William Wegman, you start to see the concocting of overt lies that they would get the camera to believe. (In a way, it was what Avedon was doing in fashion photography in the '50s, photographing scenarios. It's also connected to what motion pictures have been involved with for years: seamless special effects.) Almost all of Wegman's work with Man Ray can be read this way. Our thinking changed from believing the camera told the truth to an understanding that *the camera believes what it's told*. Our current conception is that it is a dumb beast obligated by its very nature to do so. The camera will "believe" visual lies and report them as truths. So artists started to turn the camera's obligation to record accurately that which occurred before its lens *against itself*, and, I think, by extension, against the audience's prior willingness to believe the photographic truth. There is perhaps a sadism-in-the-service-of-truth here. In the late '70s and early '80s, artists started to make the lies less obvious, to remove the seams: Cindy Sherman, yourself, Sherrie Levine, Laurie Simmons. . . . Yeah, I'm interested in all their work, and Welling, Casebere, and Kruger.

RP: When I saw Cindy Sherman's pictures for the first time, I died. There's a picture she did of herself with a diver's mask on, swimming. That picture is really it. I love that picture. That's one picture I'd be prepared to brag on. Your description seems pretty accurate, though I'm not sure whether one makes the

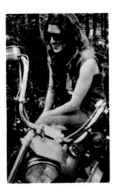

 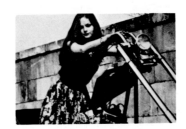

RICHARD PRINCE, Untitled (Girlfriends), 1984

"lying" more or less obvious by hiding the seam.

When I first started exhibiting these photographs, the reaction was not very . . . welcoming. Very few people liked them. But it's funny if I think about it now. People would say, "What do you mean it's a photograph of a photograph? What are you talking about?" I think what gave people a problem was that they couldn't understand what the actual object was. It wasn't like a collage. The literalness of the actual, physical object was disorienting. And the thing was, it looked like a photograph because it *was* a photograph. They'd say things like, "What do you mean it's not your photograph?" Then, what I was re-photographing was a disaster. Four men looking in the same direction. Advertisements, models, accessories, pens, watches, cigarettes. Not very accommodating images. It was hard to locate *where* the author was. Anyway, a lot of the reaction was defensive and silly. I was taking photographs; it wasn't like I was kidnapping the neighbors' ten-year-old boy.

DR: As far as your own use of the camera as electronic scissors—is there really such a tool?

RP: Sure. It's used by art directors. You sit down at a terminal and *type* a picture on the screen. Instead of pressing the shutter, you press a letter on a key. Any information you want in your picture has already been stored in the machine. It's just a question of entering a command. Aesthetically, I suppose, there's another kind of freedom involved in producing an image this way. I have a feeling that artists are becoming obsolete.

DR: Do you think of your images as dead images?

RP: No. I think my images are too good to be true.

DR: If you are thinking of the camera as an electronic scissors which obviates physical collaging, what now is being collaged, juxtapositioned, against what?

RP: My personality. "Who do I do."

When I was growing up, I liked buying what they used to call "personality posters." These things came out in the mid-60's: large black-and-white posters of your favorite film stars. I'd go into Harvard Square on Saturday afternoon with my friends and we'd each pick one out and buy one. They only cost a dollar. I picked Steve McQueen. I always thought the choosing of a personality was in itself some kind of expression. It was enough. All my friends did it. We put them on our walls, in our bedroom. I've just kept doing it.

DR: You've just made your own, personalized the technology.

RP: Yes. I guess you additionalize your own personality onto the image. The other things I had on my walls (this is when I was about 15 years old) were pictures of Jackson Pollock and Franz Kline. Not, you understand, pictures of their paintings but pictures of *them*. I was interested in the portrait of Pollock, not the paintings he did. His portrait *looked* it. Unbelievable. Posed. Self-conscious. Complete. Classic. Extreme. Just what an artist was supposed to look like.

DR: So you're involved to some degree with mapping the contours of popstar fan identification. Like a pop scientist locating identity extenders.

RP: I like to think that I make "hit" pictures. I try to put "I

Heard It Through the Grapevine" in my pictures.

DR: A hit means reciprocity, somehow. George Trow describes the hit as "it loves you because you love it because it's a hit."

RP: My photographic "gangs" are about making hit pictures: psychologically hopped up, "The best of." Instamatic ambience.

DR: Do you ever think of the "gangs" as portraits of subcults, a locating of subcults? I ask this because I'm thinking that your work corresponds quite logically to a number of social facts. The decentralization of an institutionalized, dominant view of history coincides with or is responsible for both the rise of the special-interest lobbies in Washington and the incredible proliferation of magazines that occurred in the '70s—magazines specialized for every taste, every group, and then some. So history becomes demography, the significant expression of preferences by large groups of people. If history is perceived as the official fiction, *if authority isn't believed*, then the concept of marginality, of the fringe or subcult, is obviated, because history is fragmented into lifestyle-histories, with none predominating.

RP: Specifically, the "Girlfriends" came from biker magazines. The "Girlfriends" is a new type of picture for me. The biker boys take pictures of their girlfriends and then send these pictures to a biker magazine, get them published, and then go out and buy the magazine. Strange. The consumer becomes the consumed. I don't think that's about being a subcult. I imagine it's about wanting to be recognized by yourself.

DR: It's the Fifth Beatle syndrome: wanting to be included in recorded, i.e. media, history.

RP: Yes. We're interested in Stu Sutcliff and Pete Best. We're interested not just in "what happened" but in what *actually* happened. I'm interested in people who were almost Beatles.

DR: That's one of the primary anxieties in New York, being left out of history.

RP: What becomes a legend most. I assume things like the Blackglama campaign are about power and history. Lifestyles of the rich and famous. I'm kind of interested in the lifestyles of the poor and unknown. I don't know, I can't take power and history that seriously. Second banana is interesting to me. I'm not that stupid, to want to be top dog.

DR: As your work has progressed, it's become more difficult to determine your sources. The early ones are pretty straightforward about their ad-image source, but around 1980 it opens up a lot more. Do you search for images that work together or do you just wait until they *appear* in publications?

RP: Well, obviously I can only go after certain images, those without copy or logo that fit within the 35mm frame. There was repetition, optically, in the early commodity photographs that I liked: four living-room interiors that look the same somehow but are all very different, very detailed. This similarity, this sameness within the difference, this *equivalence* was something I hoped would produce an official fiction. You know, a "look" that *appeared* to be reasonable. A look without question. It was when you turned around and went out the door that you got run over, hit from behind, flattened, floored, four on the floor, fuel injected. The boost comes in *after* you look at

it. I'm interested in exactly when and where you're going to go out of control. I'm interested in delayed density.

Then in 1980 I made a series which appeared to be an obvious extension of the other work but which was a big change: three women, each looking to the left. The change is that I simply realized you could photograph black-and-white images with color film and it would give them a more even quality. It would create an equivalence which made them look even more real.

DR: So in 1980 you began a discreet manipulation of the image.

RP: I wanted to keep up or *in* . . . I wanted to keep *in* the habit of telling the truth. I started to try to simulate the technology of how the picture originally was presented in the magazine. Hopefully my pictures would look as up to date as the latest picture in the latest magazine. You know, it was like setting up an artificial reality to deal with what was already artificial. That's what I like about Jack Goldstein's work. Anyway, the pictures I was taking were *already* directed, managed, manipulated, retouched, and so on. . . . I just thought mine had to be the same . . . just like theirs. I'm interested in the closest thing to the real thing.

DR: Do you think of each series being your own campaign?

RP: Sure. Sometimes they're like the "Sunsets" and sometimes they're like the "Cowboys." It's sort of how 20th Century Fox could put out a comedy film one month, a horror film the next, and a western after that. It's more like a movie than a campaign. I mean the "Sunsets" were an attempt to put on a *show*. I wanted the audience who came to the gallery to be entertained.

DR: Did this interest in "putting on a show" lead somehow to the "Entertainers" series?

RP: The "Entertainment Pictures" were similar to the "Sunsets" in that I wanted to, on one hand, produce a "look" that looked "bought," "produced," "managed." I started to collect actors' and actresses' publicity photos. It was like I was casting the next "show." I'd go to places where they worked. Nightclubs here in New York. I'd go backstage and watch them make up in the mirrors. Usually I got the pics from theater and nightclub managers. The movie *The Sweet Smell of Success*, a film about the manipulation of small histories à la Walter Winchell, is in those pictures. Let's see, what else? . . . I liked that a lot of these performers would appear in the newspaper columns with one name, usually their first and always respelled. Like Laoura or Nikki. The identity was so specific they each became a John Doe. I'm not sure who said it, Barbara Kruger or Kate Linker, . . . "you are not yourself." That's pretty good. You know, it's like, what do you mean I'm not myself?

DR: What accounts for the jazzed-up backgrounds in the "Entertainers"? Were you parodying the feel of those places?

RP: What surrounds the entertainer—the visual jazz, the graphics, the colors—is an environment that originally surrounded the pic when I first saw the pic. I would see these pics in windows at the theaters and nightclubs and the windows would always be blacked out around the publicity picture and the colors would be fluorescent and there'd be a lot of blinking lights about. I don't make this stuff up. I want to be faithful to the content of what the original photograph imagined.

DR: I think there is a very interesting development in the isolation of kinds of identity in your work, in the function of the people actually pictured. You begin with anonymous models, normalized, in normal environments. The "Sunsets" introduced normal human activities—a day at the beach—to photographically manipulated environments. The "Cowboys" are people *portraying* cowboys, American exotics, actors hiding their acting in real landscapes which read as settings. They are participating in their artificialized landscape quite actively. The "Generics" picture the models associated with some product, acting out, simulating their enjoyment. The "Entertainers" then move to portraits of actual actors, whose product is clearly themselves, but they are marginal actors at the bottom end of things, what remains of the nightclub circuit, waiting to crack the big time. Then the pictures of subcult stars: rock stars and artists. Now a portrait of Phyllis Diller, an actual actress, or demi-actress, whose function is entertainment but who exists outside the central spotlight, in some way, at this point. The tense that exists when one speaks of "has been" or "never was." All allow their images to jump, in one way or another, through the hoops of commerce.

In sum, I think you are portraying various levels of image power: in effect, levels of franchisement.

RP: The kinds of identity I picture are pretty much identities that are out of character. The Phyllis Diller portrait was about being out of character. It was a portrait of *her*, not her as an entertainer. It was about herself. To be yourself and still be out of character was what that portrait was about. I'm interested in being yourself and being out of character at the same time.

DR: It's a kind of multiplication or layering of identity that media culture promotes. Ronald Reagan the president-actor/actor-president is the height of that confusion. "One never knows whether to believe politicians": and here is the *concrete* (if we can use the word) embodiment of that uncertainty.

RP: I think presidential candidates should list their likes and dislikes. I think it would make it easier for people to cast a vote. Like the Dewar's profile. Favorite book. Favorite movie. What kind of sex they like. If candidate A chose *Rocky and Bullwinkle* and candidate B chose *The Jetsons* I think you'd have a pretty clear choice of who to vote for.

I think it's pretty interesting that some of the people who run for the presidency are actors, astronauts, football players, and basketball players. Personally, I'd like to be a Supreme Court Justice. I'm pretty serious about that. I don't think the appointment would be that unreasonable.

DR: Jefferson was an architect and Ben Franklin an inventor, an artist.

RP: Yeah. It's not so outrageous.

DR: And what do you imagine to be your own relationship to the imaging of power, of history?

RP: I'd like to be remembered in a movie. I know that sounds preposterous. But having someone else play me is pretty much what I think I'm already doing.

Studio Still Lifes

By Robert Cumming

The first photographic images on celluloid film were recorded in the year 1888. Ninety years later, the millions of still photographic images recorded daily and the miles of movie footage are recorded on approximately the same light-sensitive celluloid base: 35mm color. It is therefore inviting to make some facile parallels between the medium of photography and motion pictures since the latter emerged as an extension of the former back in the 1880s. One has to venture a distance back, however, to the experiments of Muybridge and Marey to a point when the two were most compatible. Still photography, a static medium, immediately aligned itself with the other plastic arts: painting, sculpture, etc.; but film with the lively arts: theater, dance, music, etc., all productions involving the cooperation of many contributors in contrast to the solitary invention of the photographer, painter, or sculptor.

In the main, one "takes" a photograph while many "make" film or motion picture. Further divisive characteristics emerge: isolating vs. developing, finding vs. fabricating, existing frozen realities vs. the complex theatrical dynamic. The photograph is the end product of a shuffling through endless visual combinations: frames of the continuum, coming to rest on the single, select archetypal, symbolic, portentous fraction of a second . . . a process of extreme compression. Film appropriates more open stretches of the continuum, and in keeping with its closest blood relative, theater, expands, employs fiction, develops characters, dialogue, drama. The commercial film seasons the plot with wardrobe, makeup, lighting, music, and were it not for the recent developments of film editing and manipulation, special effects, and rapid location changes, the end product would nearly fit our definition of opera.

Despite the convincing linearity of the finished film, its production is a confusion of non-linear fragments cemented in the final moments according to the overview: the maps in the minds of the writer, producer, and director. For instance, a production crew might film all the distant outdoor location scenes out of sequence, then return to the studio to film all the interior scenes on the sound stages. An actor on location in Washington, D.C., might be filmed rounding the corner of Connecticut Avenue, striding up the walk, and on reaching the door, he gives the knob a turn, entering. It is April. Three thousand miles away in North Hollywood, in November, the man closes the door behind him and stands in the foyer taking off his hat. No one will notice the gap on the screen as one frame speeds past the projector bulb, across the splice, to the next frame. Adjusting to the disjointed ordering of time is like trying to adjust to the idea of massing all one's sleeping hours into the first couple of weeks of the month to have the remaining two weeks wide awake. If one were in the disjointed temporal mood, all one's

bothersome driving time to and from work could be compressed into several intense commuting marathons. Celluloid time is malleable, even reversible; the stability of real time meanders and comes under question the way many of our other unquestioned perceptions of solidity and certainty stumble in the confusion of deliberate sensory re-alignment.

On the movie lot, one undergoes a formal lesson in perceptual Cubism. There, the primer is an anthology of illusion. A familiar environment is a discontinuous shell, deep space is often painted canvas, marble is plywood, stone is rubber, metals are plastic, nature is synthetic, rooms seldom have ceilings, and when the sun shines indoors, it casts a dozen shadows. Substance is unnecessary, and when terminal dry rot and termite disintegration threaten, a cosmetic coat of paint stays the inevitable. What is seen on the screen in support of drama is surface: camera-angle architecture. Our split-second sensory gaps are well-traveled thoroughfares for the traffic in illusion.

The photographs in "Studio Still Lifes" are involutions, documents of the hardware employed in the ultimate illusion. Like lessons in perceptual acuity, the objects and sets are seen in their real as opposed to their screen contexts. The energy and capital expended by the studios on even the most trivial detail are sometimes astounding. The "still" photograph rivets them for inspection. It fastens on the split second rather than speeding over it . . . the fragments one can never focus on in their true filmic context. After all, how is one to learn from illusion, unless one is "on" to the fabrication, the means by which our perceptions have been misled.

As studio tour guide through these photographs, it was difficult at times to keep the upper hand. Exposure times were lengthy spans of 15 to 45 seconds. Lighting crews walked through several exposing frames and never left a streak. It became necessary to refer to the bubble level on the camera for true horizontal and vertical, since the earlier photos were regularly askew. Wild domestic cats are everywhere in the darkened sound stages and the empty sets on the backlot, hunting for rats and mice. They rustle the dead painted leaves in the darkened jungle sets and, cornered, come bounding out of the most unlikely hollow props. A small herd of wild deer inhabits the wooded acreage above and behind the backlot. One is an albino with one horn that has butted a couple of lone studio hands. According to sixth-generation hearsay, a workman repairing the giant mechanical shark that menaces the trams of studio tourists was reported to have been accidentally clamped in its jaws and carried across the studio's artificial lake—reportage that, although fiction, tosses and mixes levels of invented reality laced with irony that seem strangely content, co-existing in predictable incongruous harmony . . . in Hollywood.

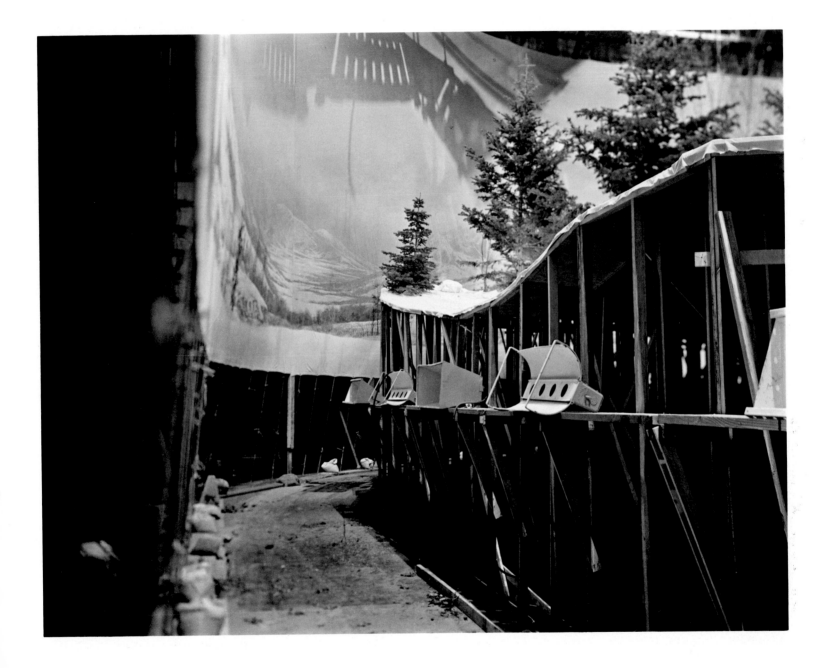

ROBERT CUMMING, Gap Between Set and Painted Backdrop; feature film,
"It's a Wonderful Life"—Stage #12, May 27, 1977

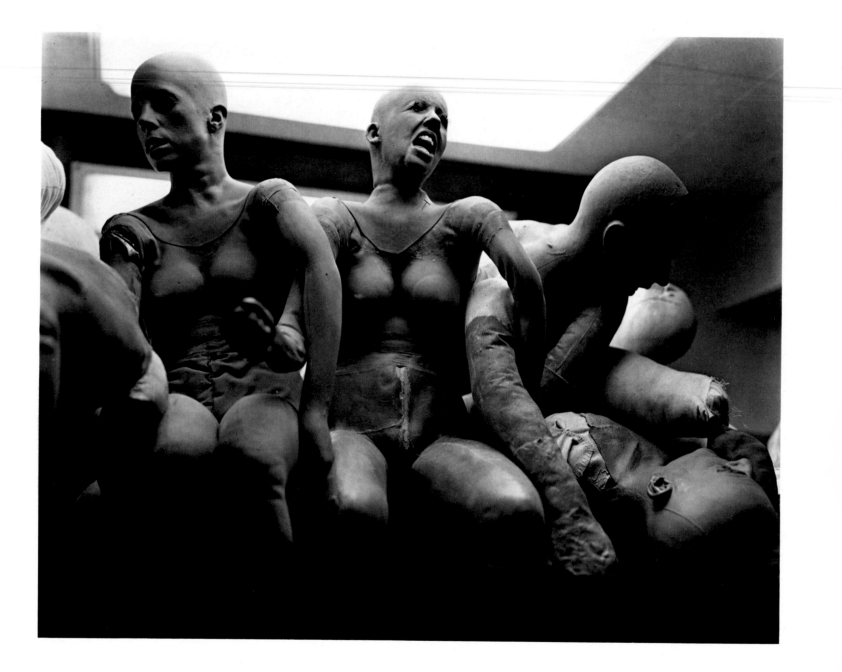

ROBERT CUMMING, Disaster Figures; feature film,
"Roller Coaster," Make-up Lab, March 21, 1977

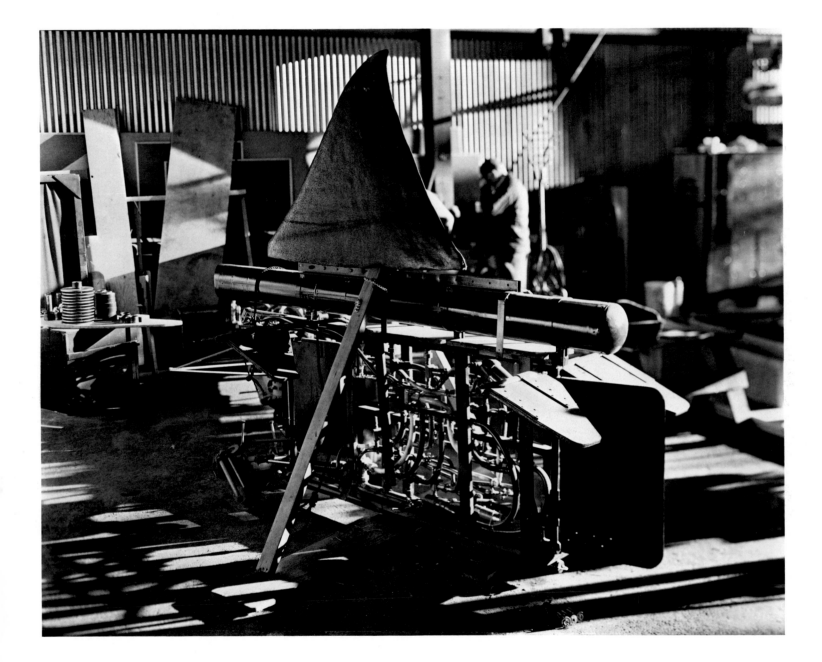

ROBERT CUMMING, Shark Fin atop Pneumatic Underwater Sled;
feature film, "Jaws II," March 28, 1977

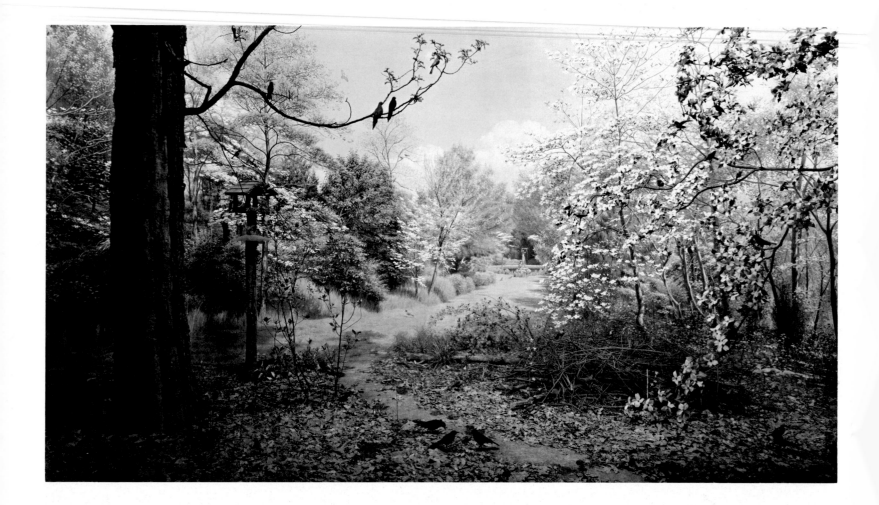

HIROSHI SUGIMOTO, Oyster Bay, 1982

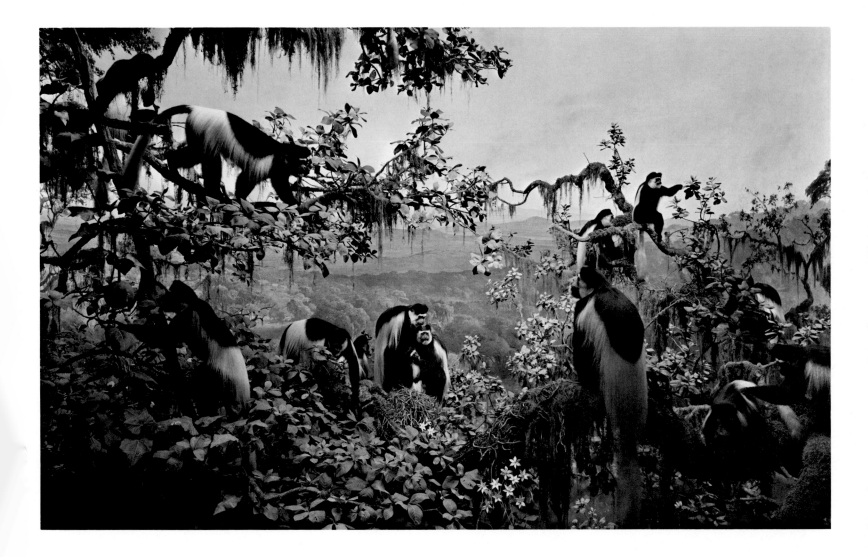

HIROSHI SUGIMOTO, White Mantled Colobus, 1982

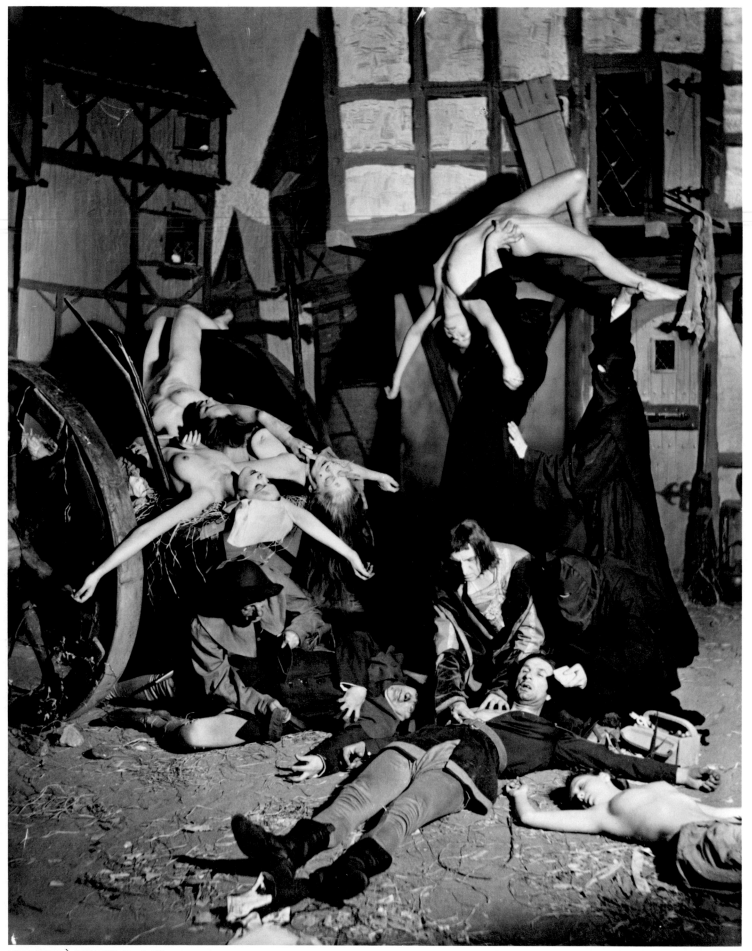

LEJAREN À HILLER, Paris Plague 1581, 1934

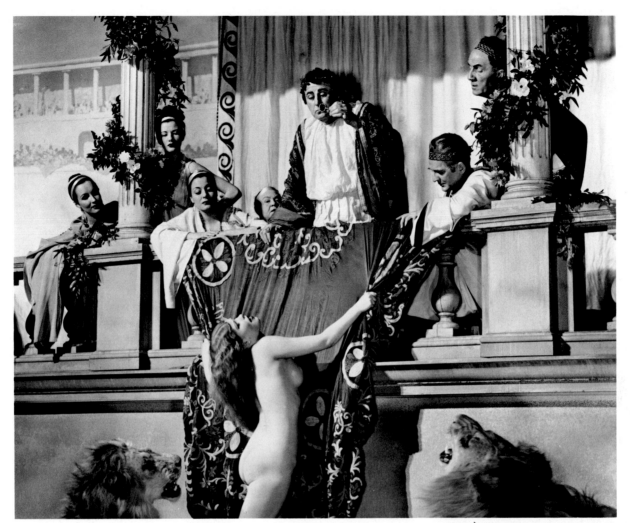

LEJAREN À HILLER, Untitled, c. 1946

Lejaren à Hiller

A pioneer in the field of illustrative photography, Lejaren à Hiller (1880–1969) is a relatively obscure presence today. During his most prolific period, in the 30's and 40's, Hiller was often credited with the first successful photographic illustrations. While others were using cameras to document reality, and magazines were utilizing mostly hand-drawn and painted illustrations, Hiller was learning to re-create history in his midtown Manhattan studio. He supervised every stage of the production of his thoroughly pre-visualized images: designing and building carefully researched sets, training and directing models, and experimenting with studio lighting techniques.

Hiller is primarily remembered today for the creation of over 200 photographic illustrations depicting the history of surgery, originally published as pharmaceutical advertisements over a 20-year period. Known for his humor, modesty, and "utter lack of temperament," Hiller had a generous attitude toward creativity, always confident that neither the commerciality nor the artificiality of his work compromised its standing as art.

In a 1943 interview, Hiller gave this advice to struggling young amateurs: "If a man wants to strangle his wife and throw

her in the kitchen sink, let him do it any way he wants to. If he's doing it awkwardly, or not the way I'd do it, all right— it's a good job so long as he gets her into the sink, completely strangled."

LARRY FRASCELLA

21

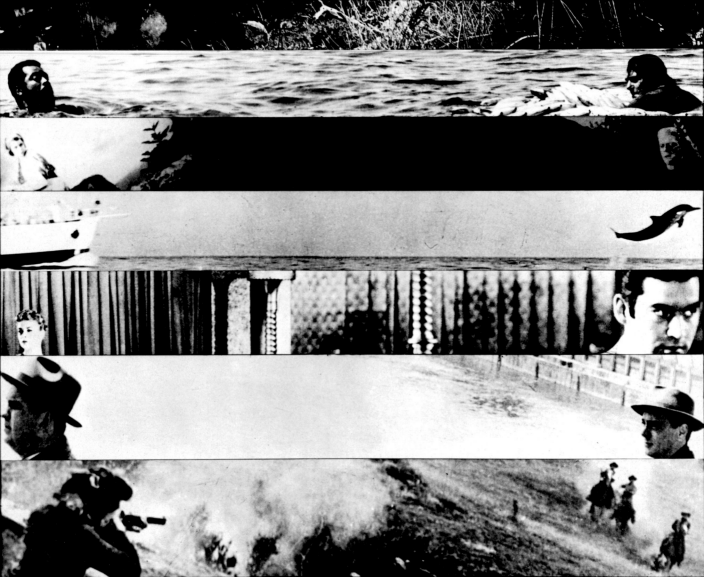

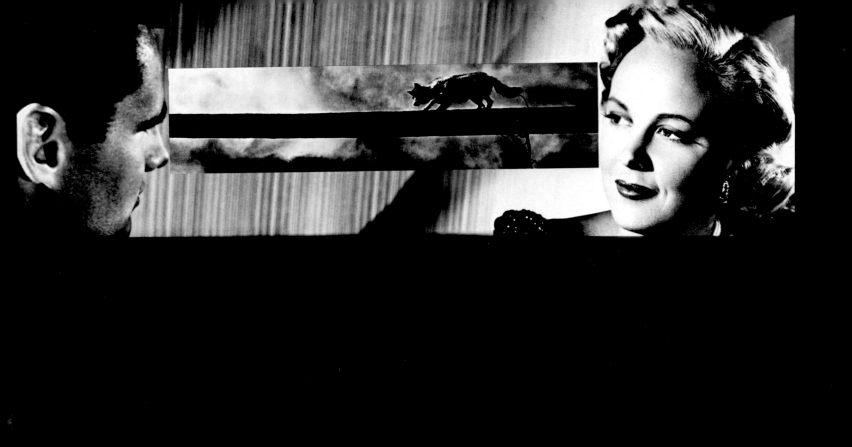

OHN BALDESSARI, Man and Woman with Bridge, 1984

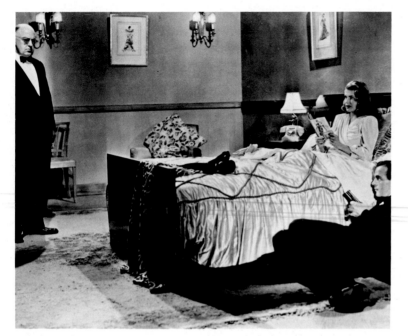

Still from the movie "Black Dice" or "No Orchids for Miss Blandish," 1948

Black Dice

By John Baldessari

This piece is derived from an English gangster film, *Black Dice*, a movie I've never seen. I remembered that Titian had done sections of landscapes as etchings and then set them on the wall as one continuous landscape. That intrigued me. Since I'm interested in things exploding and imploding, and being disjunctive, that idea seemed natural to try. While I cut the original image up two ways vertically and two ways horizontally into the nine parts, each section did seem like a separate composition, which was what I was trying to do. I wanted to retain part of the original movie still in each of the nine sections, so I just zeroed in on the most obvious things in each section—a lamp, telephone, or shoes, then isolated the object either by geometric devices, a circle, triangle, or square, or sometimes just by letting the subject dictate the frame. The rest of the print is conventional etching technique, primarily aquatint, since that's what I really wanted to explore. The complete original movie still has been included when I exhibit the prints, but each print could be shown separately.

I think I am intrigued with any movie still that points to some kind of personal interrelationship and how that is registered on faces and with props. I'm also attracted to movie stills where the reading is not clear but appears clear. Why is that woman in bed seemingly not alarmed? Why is the man with the gun crouched behind her dressed in a tuxedo? The common denominator is that the man at the door has a tuxedo on too. Why is she elegantly dressed but in bed? It looks like some bedroom comedy yet there is a gun involved.

A lot of formal devices I am using in these pieces I had used in the mid-'50s in a series of paintings. The approach was almost the same except for the larger scale of the paintings. A friend of mine worked for a billboard company and would give me the extra sheets. Each sheet would be a section of a larger billboard, much like what we have here. I would mount those and paint out sections, leaving certain parts of the original photography.

I never really considered photography as a medium, as an end in itself. I never

have given much obeisance to any medium. I always thought it was to serve me, not for me to serve it. So I've taken photography for just what I want. That's another reason I can do something like this—I didn't see it as so different from a straight photograph. Nor would I see a straight photograph as so different from a print. For me, its all dark and light marks on a surface, just done in different ways.

The film *Black Dice* (1948), with Jack La Rue, Linden Travers, and Hugh McDermott, is based on a detective story by James Hadley Chase entitled *No Orchids for Miss Blandish*.

Black Dice, a portfolio of nine color etchings in aquatint, photo etching, soft ground, and sugar lift, was printed by Peter Kneubühler of Zurich and published by Peter Blum Edition, New York.

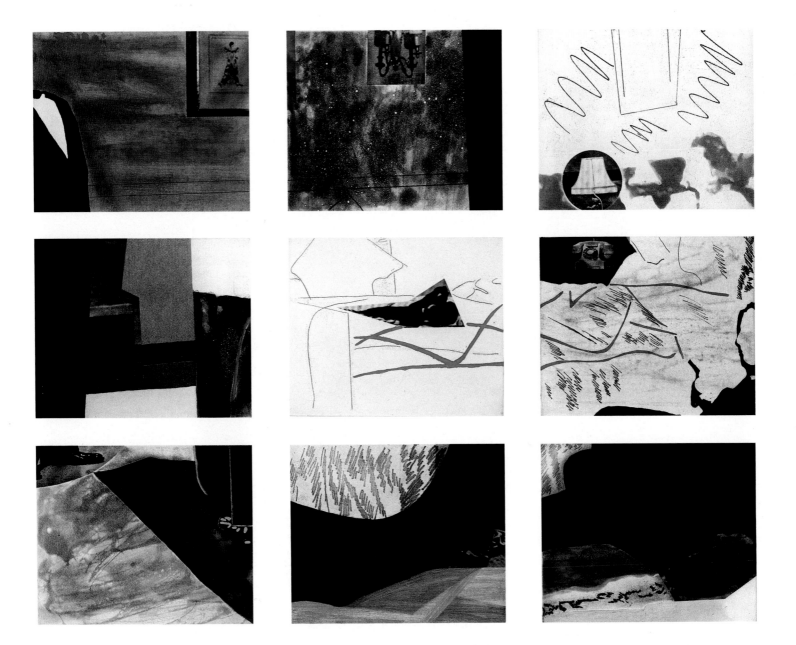

JOHN BALDESSARI, Black Dice, 1982. Consisting of 9 color etchings
in aquatint, photo etching, soft ground, and sugar lift

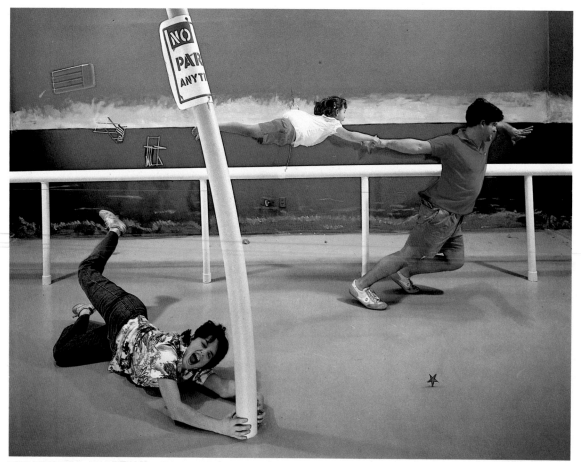

NIC NICOSIA, Near Modern Disaster #8, 1983

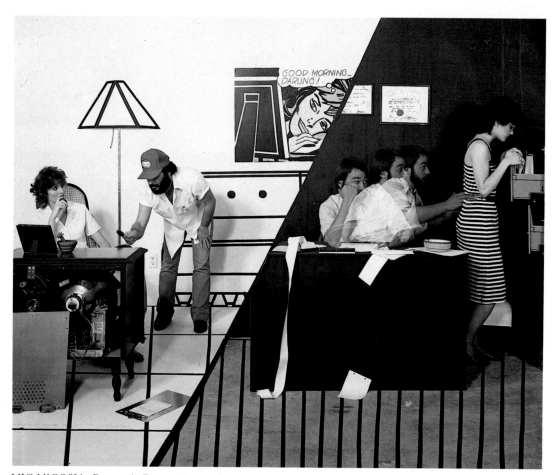

NIC NICOSIA, Domestic Drama #2, 1982

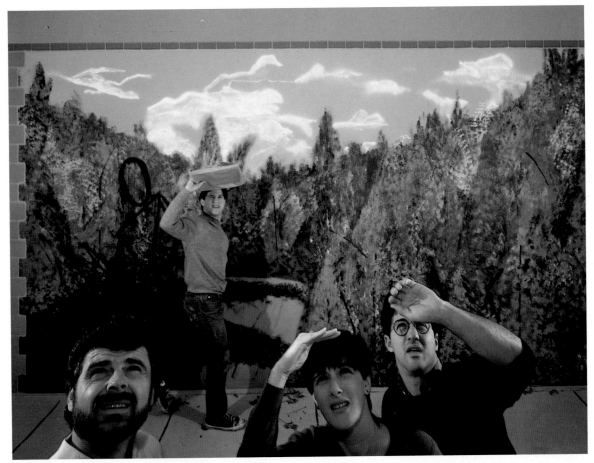

NIC NICOSIA, About Looking, 1984

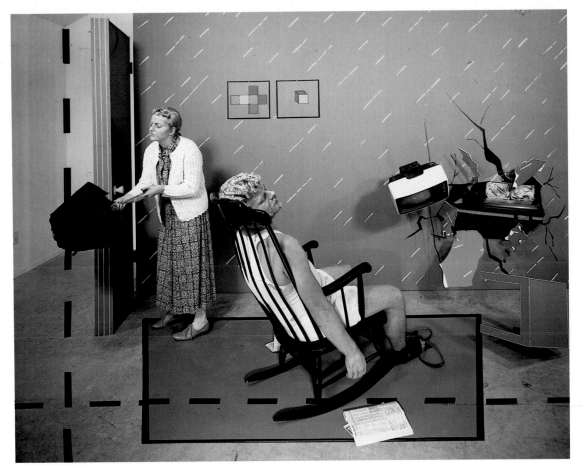

NIC NICOSIA, Domestic Drama #7 (Near Modern Disaster #1), 1982

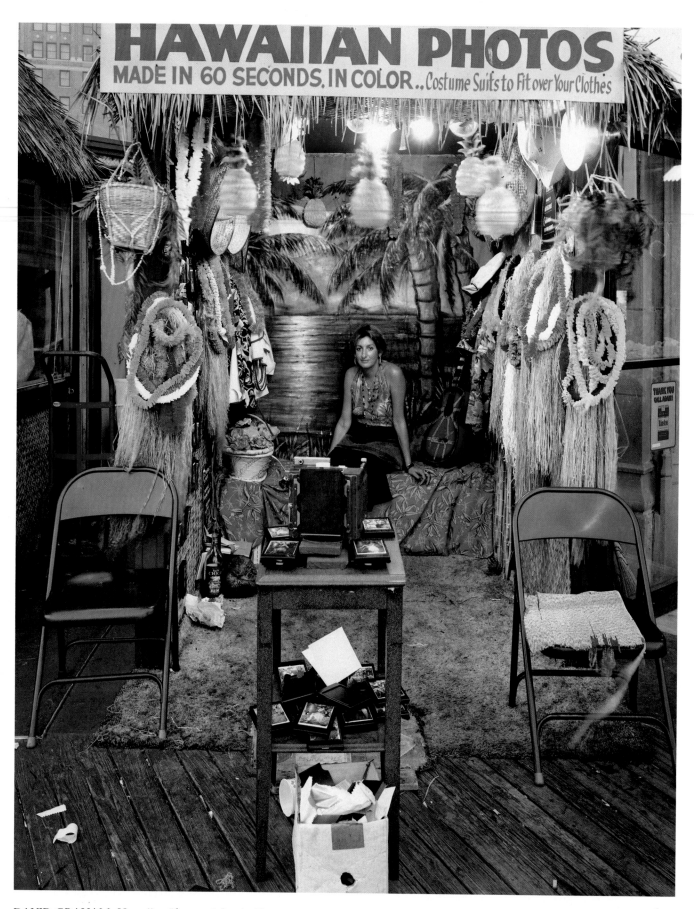

DAVID GRAHAM, Hawaiian Photos, Atlantic City, 1980

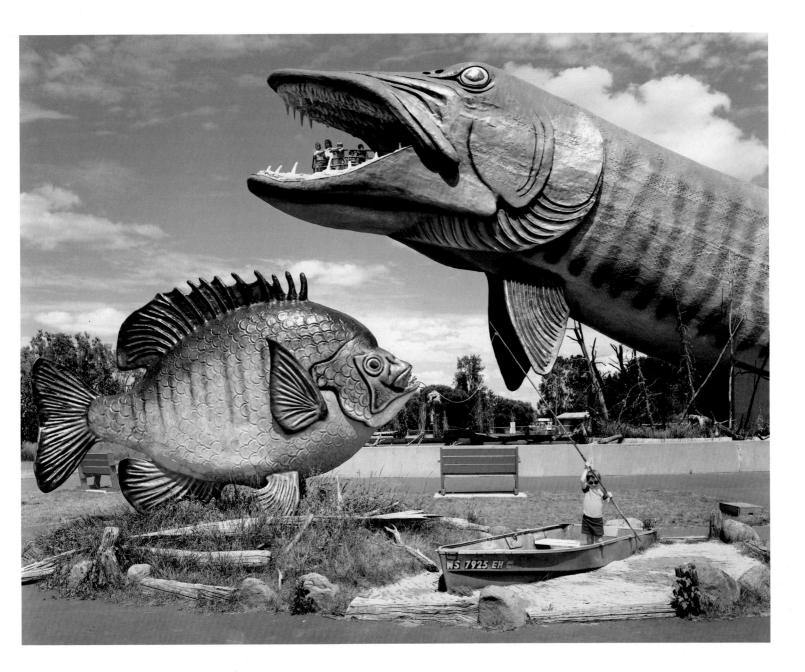

DAVID GRAHAM, Freshwater Fishing Hall of Fame, Hayward, Wisconsin, 1984

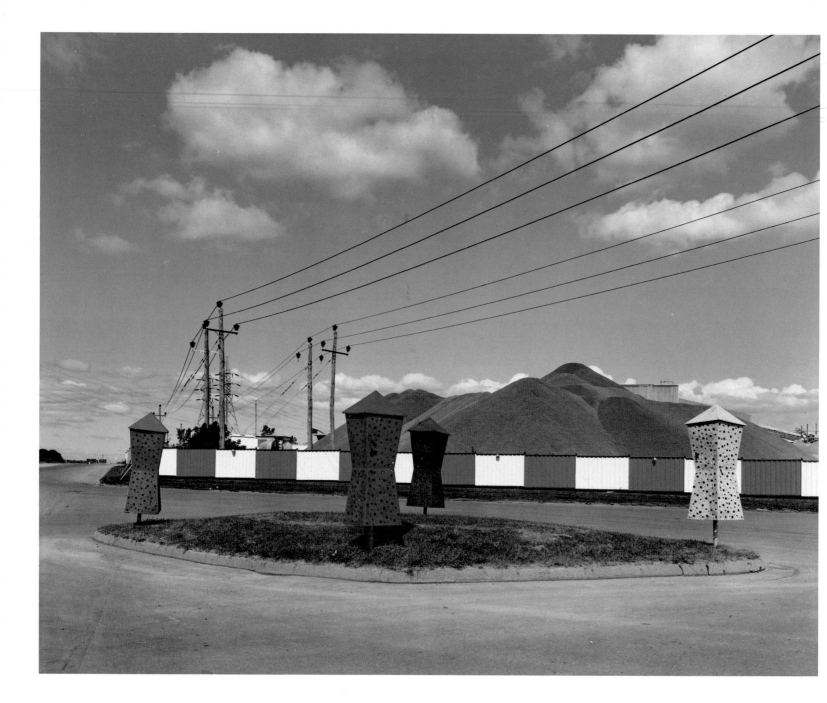

DAVID GRAHAM, Drive-in Theater, St. Eustache, Province of Quebec, Canada, 1982

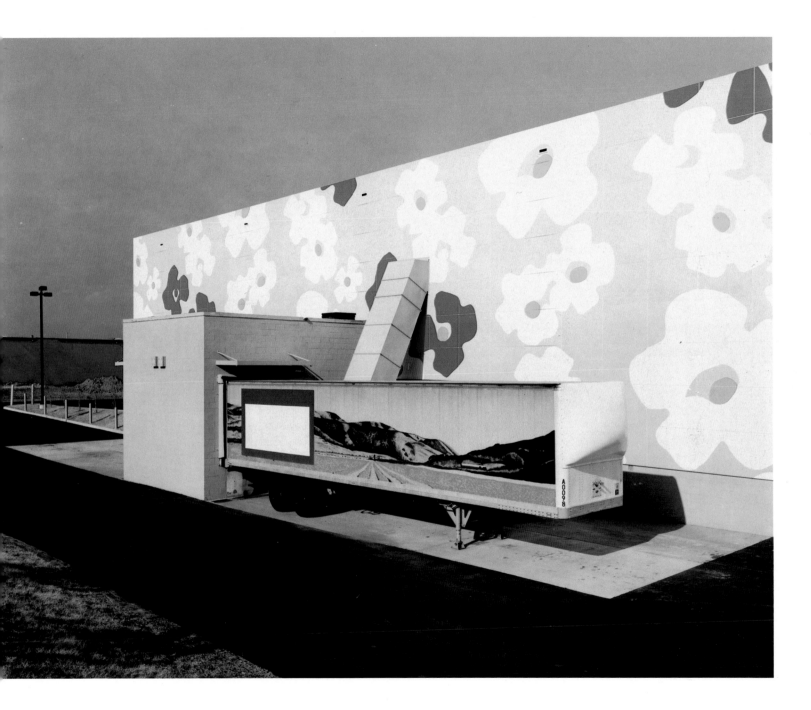

AVID GRAHAM, Best Company, Langhorne, Pennsylvania, 1981

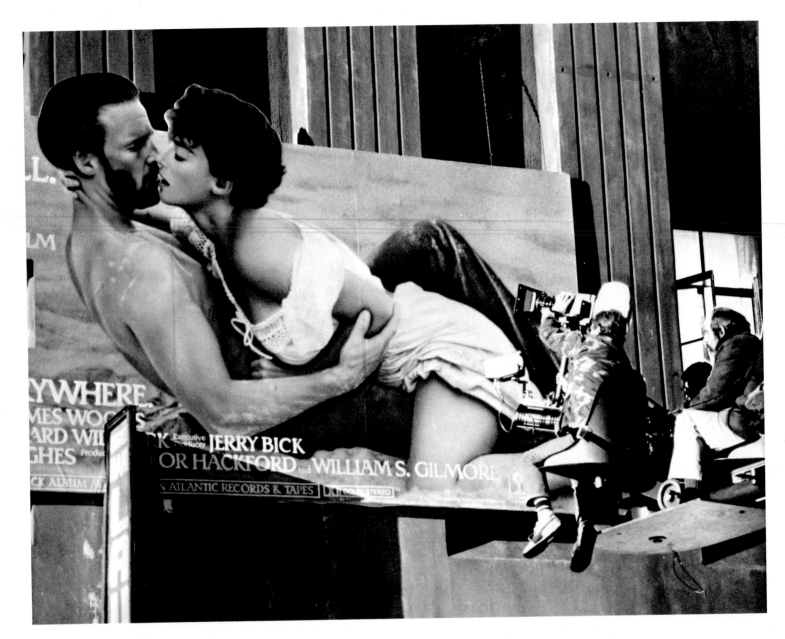

Brian DePalma's Body Double

By Susan Dworkin

Brian DePalma's recent film Body Double *contained enough violence and eroticism to sustain his reputation from his previous films* Scarface *and* Dressed to Kill. Body Double *developed around the gruesome murder of a beautiful woman, witnessed through a voyeur's telescope. Much of the film is derived from the backdrop of Los Angeles and its billboards, the television screen and pornographic video, as well as the voyeur's telescope view of the flesh of a beautiful woman. The film is constructed out of cinematic reference to such masters as Hitchcock, and it includes the shooting of a horror movie within the movie.* Body Double *is a comment on the thriller genre and also on the illusions of the imagery that infiltrates our lives as spectators. The characters are expressed through the imagery they either promote or consume. Flesh is the raw material, the commodity that forms the spectacle. The repeat glimpse through the tele-*

scope lens forms a direct analogy to the camera and the inherent voyeurism of photography. At one point the screen is filled with a desert landscape, then the camera moves back to reveal the landscape as a movie prop, further reinforcing our disbelief in reality. Susan Dworkin was granted access to the shooting and editing of the film. Her insights into the calculated artifice of Body Double *provide a study in deception.*—Ed.

In March 1984, dirty thoughts hung quite literally over Los Angeles. Across the broad, hazy sky stretched billboards in Panavision proportions featuring naked or nearly naked people, all perfect. They invited you to spend the weekend. They bandied the latest movies. *Blame It on Rio*, butt first. Rachel Ward, her blouse coming down, her skirt sliding up, as Jeff Bridges reached for her with open mouth and bulging biceps. Even the

upcoming Olympics were billed sexily. Carl Lewis's beautiful body leaped off the sign on the way to the airport. There was sweat in the cleavage of the girl in the pink aerobics outfit, hawking calorieless soft drinks above La Cienaga.

The display of bodies on the horizon imposed its standards on the bodies on the street, where unprecedented masses of plain people were apparently consumed with the cultivation of fleshly perfection. There was this general feeling of continual coitus; mega-flesh above pressing on real flesh below. Those who were not in on the act recognized each other immediately.

Across the street from Kathy Gallagher's and Joe Allen's, lively restaurants for the up-and-coming, there was a men's gym with a see-through facade, so while you waited for a table, you could watch the beautiful boys sweat and pulse. In a comic-book store on Sweetzer, full of little kids trading and collecting, buttons were sold that said "I'd Like to Sit on Your Head" and "A Hard Man Is Good to Find." Nobody paid any attention.

"This picture deals with reality and unreality all the time," director of photography Steve Burum says, "it moves back and forth between them. You start out with the unreality of making the [vampire] picture, which is presented to you as real. It's

done very colorfully and romantically. Then Jake walks out of the movie studio and it stops being romantic because he hits reality. You shoot the reality differently. Not such warm colors. More blue. Instead of the windows being perfectly balanced, they're burned out. You let them be overexposed, so there's a hot, grungy feeling. The composition of the shots, instead of being perfectly balanced, becomes stressed, a little asymmetrical. Even Jake looks less good in the harsh light of reality. When he gets into Sam's house and Sam shows him the girl, you slip back into a romantic style. Instead of wide-angle lenses to throw the perspective, instead of having everything very sharp, you use a long lens to compress the depth and bring the background closer to the foreground. Everything becomes softer. Rounder. Friendlier.

"The reason I chose to do the romantic scenes with a compressed lens is because the first time you see the girl is through a telescope. It's very, very compressed. Even when the girl is not being seen through the telescope, you still want to keep the romantic convention. You don't want to use the telescope to perceive it, but you want to convey the same feeling, which is that the woman is doing something erotic and sexy that arouses

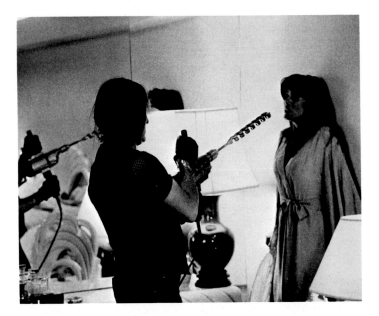

you. And then, you keep the same wonderful feeling when she is being murdered."

DePalma's storytelling, his visual technique, and Burum's and Gerry Greenberg's manipulations with the light and the cut do more than make the mystery proceed. They bring us and Jake Scully to a not-so-subliminal conclusion.

That the way the woman is beautiful, the murder is beautiful.

That the way the woman is unreal, the murder is unreal.

What the visual code of the times wants to know is: is the murder unreal enough?

. . . he hit her breakaway sleeve instead of her body and the drill broke the mirror so there was glass all over the floor and finally she fell on her back and Gregg stood over her, motivating himself, he said, by a combination of "rage and fun," and we see the drill protruding down between his spread legs for the final thrust. "The crew cheered and laughed," Deborah said. "Boys with their toys. And, of course, Wilma was sitting there with the script, practically retching. . . ."

The "weird feeling" that Deborah had watching the dummy get drilled is just like the feeling that the audience is having. It's a terrific feeling; you've seen your own death and walked away unscathed. Once again, Mom was right. The director yelled "Cut." Joe Napolitano stopped the blood-spattering machine. And we all went out for pizza, having had a good time at the movies.

Susan Dworkin's book *Double DePalma: A Film Study with Brian DePalma* is published by Newmarket Press, 3 East 48th Street, New York, New York 10017.

Divine Revolt

By Joel-Peter Witkin

No one could explain what life and death were. No teacher, book, radio broadcast, or television program could tell me. I concluded that only the Creator of all things, G–d, maker of death and life, would know. I wanted to know, from him!

An opportunity to know came to me when I was seventeen. My fascination with seeing and observing things was based on the uncertainty of being alive. I wanted proof of existence itself! I became interested in photography because I felt that it could supply that proof. I had read several beginners' books on photography, and purchased a used Rolleicord camera and film for it. My father, an Orthodox Jew, who divorced my Christian mother for religious differences, told me that he had read an article in the *New York Daily News* of a rabbi who had seen and talked to G–d! I was ecstatic with the prospect of meeting such a man. Now it would be possible to know what death and life were from a holy man who had seen G–d! I called the synagogue and got permission to photograph the rabbi. My first photograph, the very first piece of film I would expose, would be of "The Rabbi Who Saw G–d." I was to photograph him in his study, that was the very same place where G–d appeared to him!

That day arrived. I was escorted by a young rabbi to a great pair of wooden doors. He told me to knock, and he left me there. I knocked and entered with instant disappointment. I imagined a room flooded with light, angels, and suns. I expected rainbows and constellations with the rabbi standing, shining and larger than a mountain. His voice would be of thunder. And he would tell me what death and life were.

Instead, I found a tired, sleepy little old man sitting in a corner of a large dusty study. I did not see G–d within the rabbi or the presence of G–d within the room. I decided to photograph the rabbi anyway, hoping that perhaps, if I couldn't see what I had imagined to be there, perhaps the film would reveal it. Perhaps G–d would appear on the film when it was processed. Somehow, I knew that it wouldn't turn out that way. I closed the great doors still believing that the sight of G–d would give life reality and purpose. I believed that knowledge would come, and photography would be the means to see and relive my fantasies. These fantasies had no place in the ordinary but only in the most secret and hidden things—in the strange, the bizarre, the invisible.

When I closed the great doors of the rabbi's study years before, I still believed that *reality* meant only one thing—the presence of G–d before me. Until that happened, I could have no identity, no purpose. I then was a man in my late twenties whose sole ambition was to see G–d and whose compulsion was to make photographs. In my impatience to know reality and therefore to understand myself—I decided to combine my ambition and my compulsion. I could not longer wait to *see* G–d —therefore, I would *create* the image of G–d! In order to know if I were truly alive, I'd make the invisible visible! Photography would be the means to bring G–d down to earth—to exist for me in the photographic images I would create!

I chose to incarnate Christ as G–d, because I believe he is G–d and because he still represents the living belief of this culture. He *is* the symbol, regardless of historical existence representing REDEMPTION and the end of suffering and confusion.

The series of photographs resulting from this concept was called "Contemporary Images of Christ." I will state at this time that I have never nor will ever describe the photographs I have produced or will ever produce as being "pictures." They

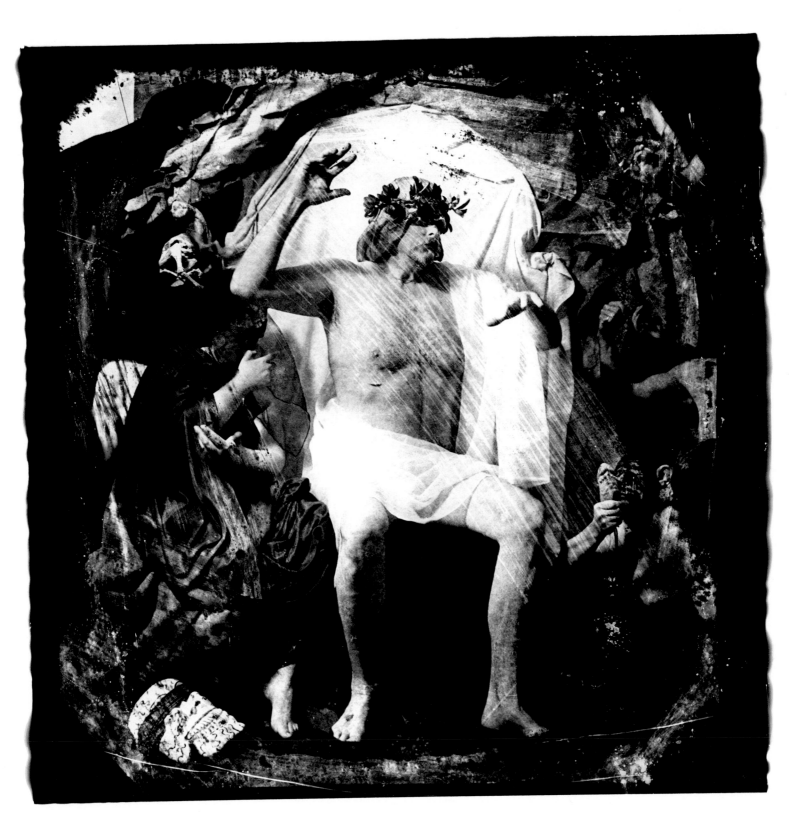

JOEL-PETER WITKIN, Decadent Artists, New Mexico, 1983

are "images of things not actually present in reality, other than my own reality."

My brother was working on a painting that incorporated freaks. He asked me to go to a freak show in Coney Island, Brooklyn, New York, and photograph different views of a three-legged man, a dwarf called "The Chicken Lady," and a person named Albert Alberta, a hermaphrodite.

I photographed the three-legged man, "The Chicken Lady," and the hermaphrodite, with whom I had my first sexual experience. The freak show became my home, my real environment filled with living fantasies. Unfortunately, the freak show was moving to the South. I wanted to travel with them, but they didn't need a photographer and I wasn't a freak. Instead, I stayed in New York City and worked in commercial photographic studios. With the freak show gone, I began to create my own environments of personal fantasy in order to photograph them.

The visual influences which had the most important effect upon me at this time were paintings dealing with religious and esoteric themes such as those by Cimabue and Giotto because of their depiction of the frozen emotion of the sacred. Rembrandt because he made the sacred human. The Symbolists, Félicien Rops, Gustav Klimt, and Alfred Kubin, because their work dealing with dreams, perversity, and satanism somehow challenged the sacred yet seemed an unavoidable part of the sacred. Balthus and Max Beckmann because the former satisfied the appetite of his vision, the erotic and the voyeuristic, while the latter, dealing in the melding of pain, lostness, and death, hoped to find what was "real" by objectifying it.

Another form of visual influence was comic strips depicting contemporary myth-heroes. I could never accept any symbol for its intended use, in any form. This applied to scripture, myth, and all art forms, even to the simple stories of the comics. Therefore, Superman became the hero of goodness, the secular Christ; Batman was the Lord of the bird world and darkness, the Anti-Christ; Wonder Woman—the Amazon of impotence, the Virgin Mother.

At this time, I wanted no personal contact with other photographers, preferring to work out my own vision in isolation. The only photographer whose work strongly influenced me was August Sander. His images were faithful to the character of his subjects. He was able to go behind the mask of each of them with the most straightforward use of the medium. Sander worked with the reality of his time, in the setting of his native land and the consciousness of its people. My work would have none of these qualities. I didn't believe in the reality of time or space, the consciousness of all people was outside my own. To me people were only masks. My interests would not be to reveal what the individual subject chose to hide but instead to make the qualities of the hidden more meaningful. This is why I could engage the world on my own terms. I could deal with people only by superimposing my own mask on theirs. The work of August Sander had the impact of his reality, of his convictions. My work would have the impact of my irreality, of my doubts. The images I'd produce would not necessarily be aesthetic but would represent source material of an individual's rage of confusion and need to find the Self. I wanted my photographs to be as powerful as the last thing a person sees or remembers before death.

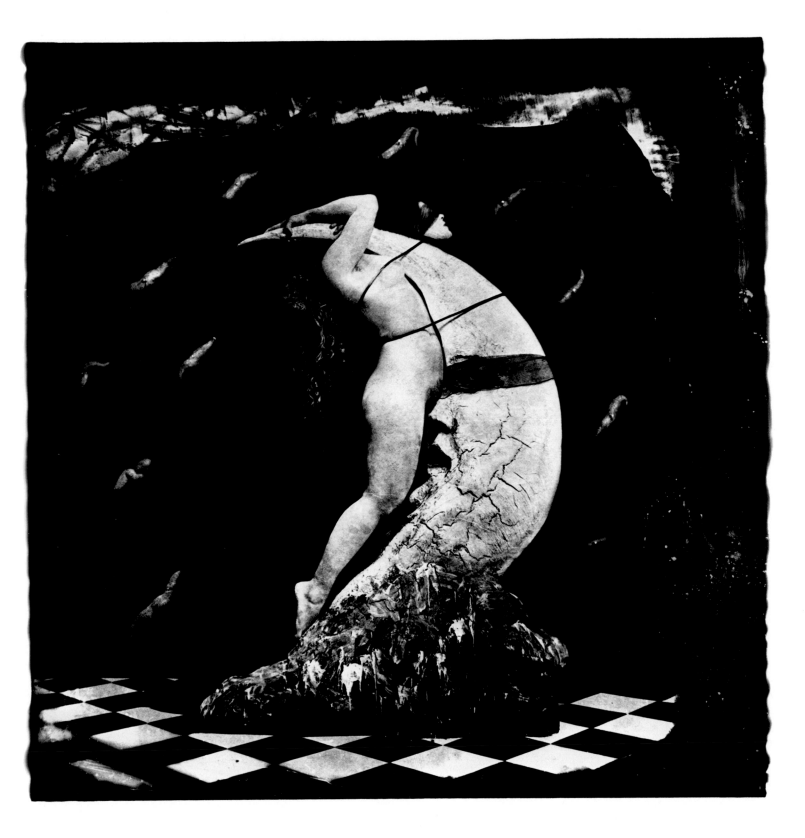

JOEL-PETER WITKIN, Woman Masturbating on the Moon, New Mexico, 1982

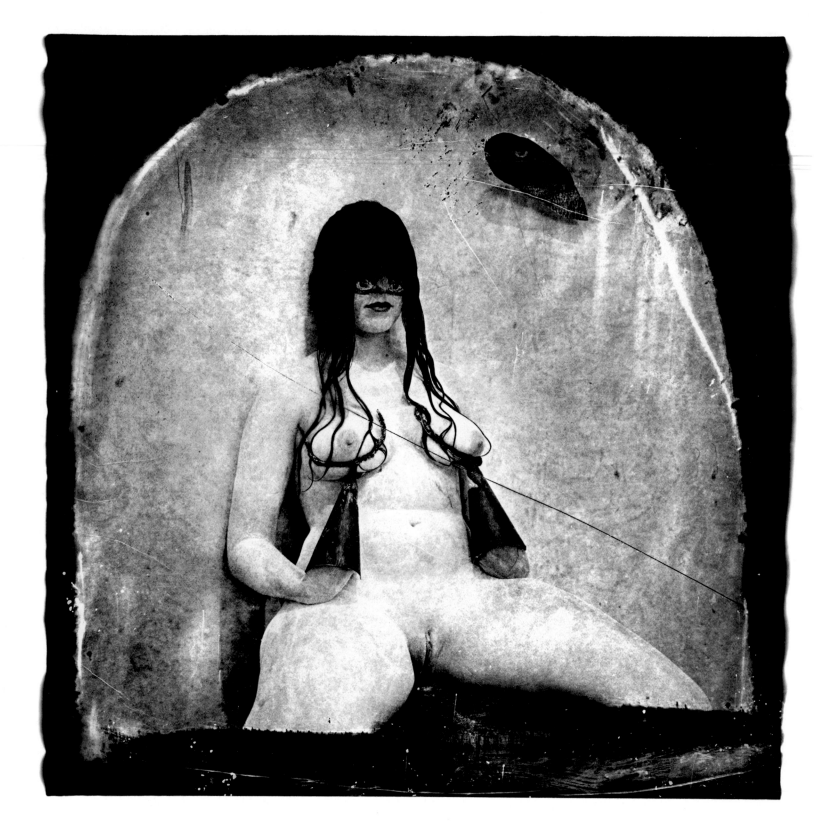

JOEL-PETER WITKIN, The Bra of Joan Miró, New Mexico, 1982

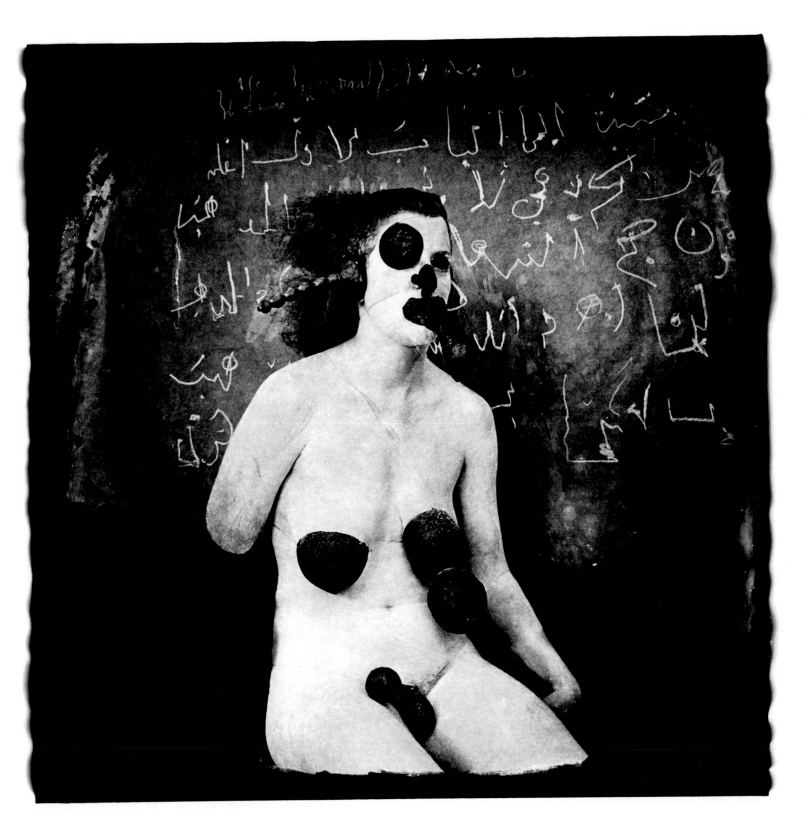

JOEL-PETER WITKIN, The Collector of Fluids, New Mexico, 1982

The search for new subject matter has moved Witkin further into the sexual demi-monde, and more clearly into the position of metaphysical pornographer. The sacred appears increasingly linked to the erotically profane. Certain sectors of the homosexual milieu have proven particularly fertile for the photographer, and while touristing in other people's reality—to borrow from Susan Sontag—Witkin has realized some of his most extreme compositions. In contrast to Robert Mapplethorpe, who incidentally is one of the biggest collectors of his work, Witkin looks beyond surface formalism. His images are not high-fashion renditions of sexual fetishes but intense meditations on the psychological impulses and ritualistic instincts which stimulate extreme forms of sexual behavior.

HAL FISCHER

My life wish is to be connected with a place we can't know, hope to go, or hope to be.

JOEL-PETER WITKIN

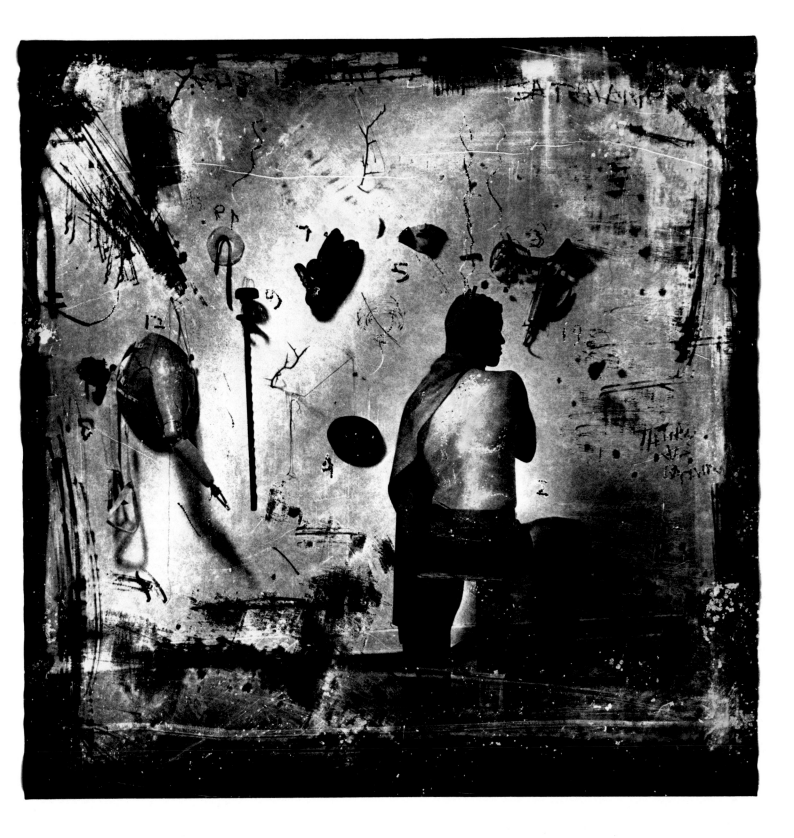

JOEL-PETER WITKIN, The Sins of Joan Miró, New Mexico, 1981

The Future of Photojournalism

By Fred Ritchin

Photojournalism has been the beneficiary of the twin notions that "the camera does not lie" and that journalism is impartial, a public misperception that has both awarded the medium a powerful platform and helped to stunt its growth. Now photojournalism is increasingly moribund, being used to a greater extent in artificial and lifeless ways while facing serious editorial and technological challenges to its credibility. Its revival and future success lie partly in its reconsideration, in first admitting its tenuous relationship to reality and then in identifying and bolstering its intrinsic strengths, some of which became newly apparent at a recent symposium on Latin American photography.

The reputation of photojournalism as a direct, virtually unmediated transcription of reality and an easily understood, universal language helps create the impression that a photojournalist's imagery can be quickly comprehended and his or her methodology trusted. Whereas advertising imagery is made with the declared intention of selling products, and photographic art is from the start considered subjective, and the validity of snapshots can be compared against the actual relative or friend depicted, the photojournalistic image is perceived as describing far-flung people and events in a straightforward, impartial, almost mechanical way.

This notion usually absolves the medium from arguments about the truth of a depiction, and from suspicions about the points of view and bias of picture-takers and editors. As long as a photograph was taken where and when the caption says it was, it is generally thought to be accurate and, at times, even more reliable than the testimony of a human eyewitness. However, photojournalism, even of the candid variety, is hardly unmediated. Each photograph is a sliver of time and space chosen from an infinite number of other possibilities to represent reality on a small, two-dimensional rectangular piece of paper. The human who selects the sliver and makes the image is interpreting a situation according to his personality and intelligence and with varying degrees of skill, which also may be modified by a knowledge of what images sell or please his employer. The resulting images may be revelatory, meaningless, or wrong. As Fidel Castro put it in a speech at a 1984 conference in Cuba, a photographer can choose, with very different results, to concentrate on Havana's peeling paint or on its sophisticated health care.

The images finally selected for publication also reflect and sometimes defend the editor's ideas, and those of the writer and the personality of the publication itself. The photograph is surrounded by words—headlines, captions, text—that direct its meaning and attempt to resolve its ambiguities.

But despite these editorial modifications, the photograph still emerges as a highly believable representation of events. This is because readers are not fully aware of the processes by which photographs are made and selected, and also because of the simple mechanical nature of the camera, familiar to almost

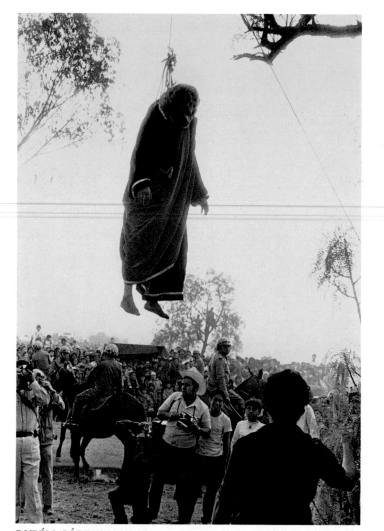

RUBÉN CÁRDENAS PAS, Good Friday, Ixtapalapa, Mexico, 1978

everyone through wide use. The perception of the camera's straightforward vision is accentuated by downplaying the photographer. While writers are given bylines, photographers are often given credit lines that are barely visible. Writers are required to assume responsibility for the facts and judgments in the article, and its general tone and point of view, while it's often presumed that photographers simply record events like fast-moving stenographers.

Even the diluted realities of editorial photography are being rapidly replaced by other, more artificial forms of imagery that can be constructed according to preconceived specifications. The stars of magazine photojournalism, who used to include the great picture essayists, are often now illustrators who can find clever, entertaining ways to make images that fulfill stylistic conventions. While newspapers in this country still tend to adhere to traditional, if mostly uninspired, photojournalistic practice, the recording of society's stirrings is rivaled and, in magazines, often surpassed by a legion of editorial photographers adept with strobes and portable studios whose skills allow them to make the visually unremarkable seem interesting and transform the exciting into the sensational.

A compelling need for dramatic visualization has, however, a long tradition in photojournalism. W. Eugene Smith's "Span-

42

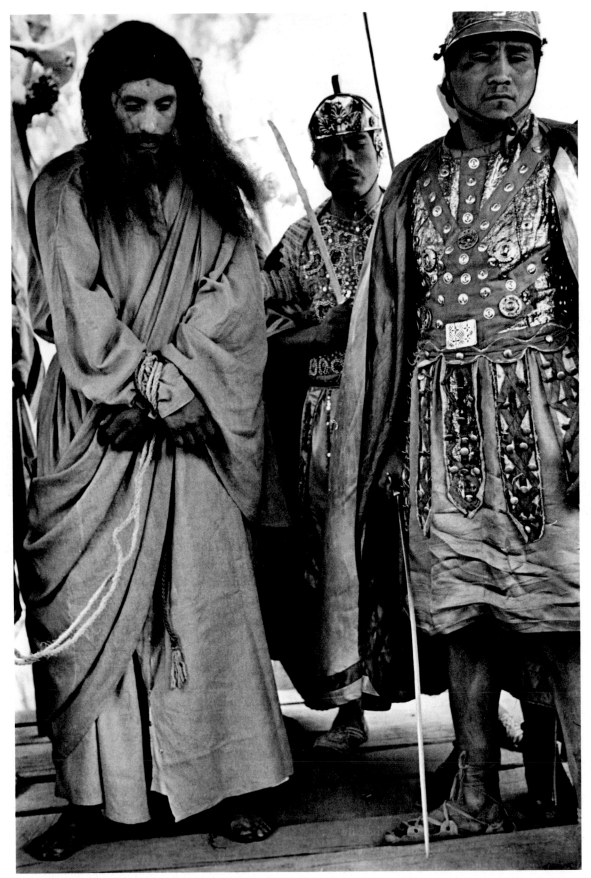

NACHO LÓPEZ, La Pasión, Ixtapalapa, Mexico, date unknown

ish Village," considered one of the greatest picture essays ever made, showed the directorial skills of the photographer very much in play. In his 1952 book *Words and Pictures*, Wilson Hicks, who had recently left *Life* after a 13-year stint in positions that included picture editor and executive editor, describes the making of "Spanish Village":

"A majority of picture stories of a nonspontaneous character require a certain amount of setting up, rearranging and direction. In dealing with them the photographer's purpose is to re-create an actuality in substance and in spirit in such a way as to make clear the ideas which the photographs are intended to convey and to give coherence to their compositions. In this category of stories was Smith's moving and impressive 'Spanish Village' (*Life*, April 9, 1951). Life in the village was not a series of acute, ready-made crises; except for the death of a patriarchal old man, it was, on the surface, routine. But beneath the routine was a continuing and passive tragedy of primitivism and poverty. This was the story's theme; Smith's problem was how to develop it most vividly and dramatically in pictures. The everyday actions of the villagers were casual, and if on this assignment Smith had 'faded into the wallpaper,' his pictures would have been casual, and indifferent too. By explaining to the villagers that he wished to tell who they were and what they did in the most interesting possible manner, and to draw the full import and most suggestive meanings from their actions and appearances, Smith made actors of them, but actors in a drama held strictly to the facts. For the camera they enacted consciously what they theretofore had done unconsciously; they did what they were used to doing better than they were used to doing it. In re-creating an actuality, Smith gave to it more power and beauty than it had had originally."

It is questionable to which canons of journalism asking people to do "what they were used to doing better than they were used to doing it" conforms. Smith seems to have been intent on creating images of universality rather than specific images of the village of Deleitosa. His photographs appear as icons of romantic humanism, the fulfillment of Smith's artistic and personal vision, a post-war affirmation of the cleansing values of rural, pre-industrialized society.

Despite serious doubts about Smith's methodology, universalized images, depicted sincerely and passionately, are more defensible than photographs whose artifice is meant largely to engage the upscale consumerism that is the obsession of many contemporary magazines. While today's directed, posed, or set-up photographs have abundant precedents, contemporary editorial photography is striking for its large-scale, skillful avoidance of and even retreat from an investigation of the deeper strains of life under a thick veneer of strobe lights, dramatic posturing, and formularized picture stories. People are not asked to re-create their lives to get at the core but to make their lives conform to the prevailing fantasies the publication cherishes.

In part, this accelerating trend appears designed to keep up

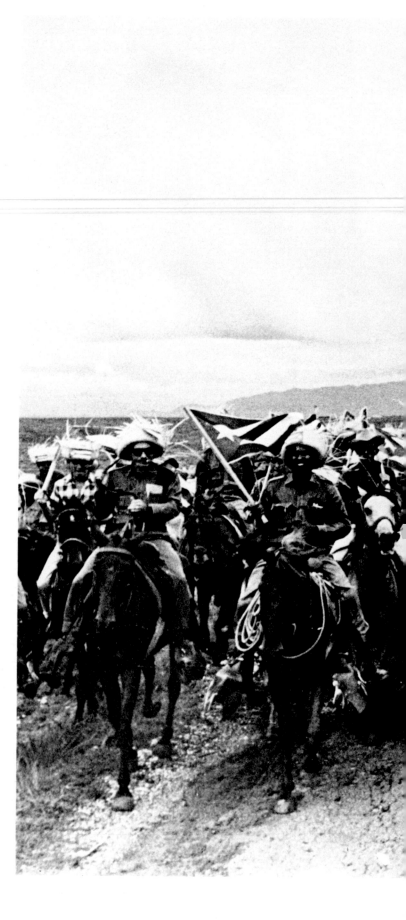

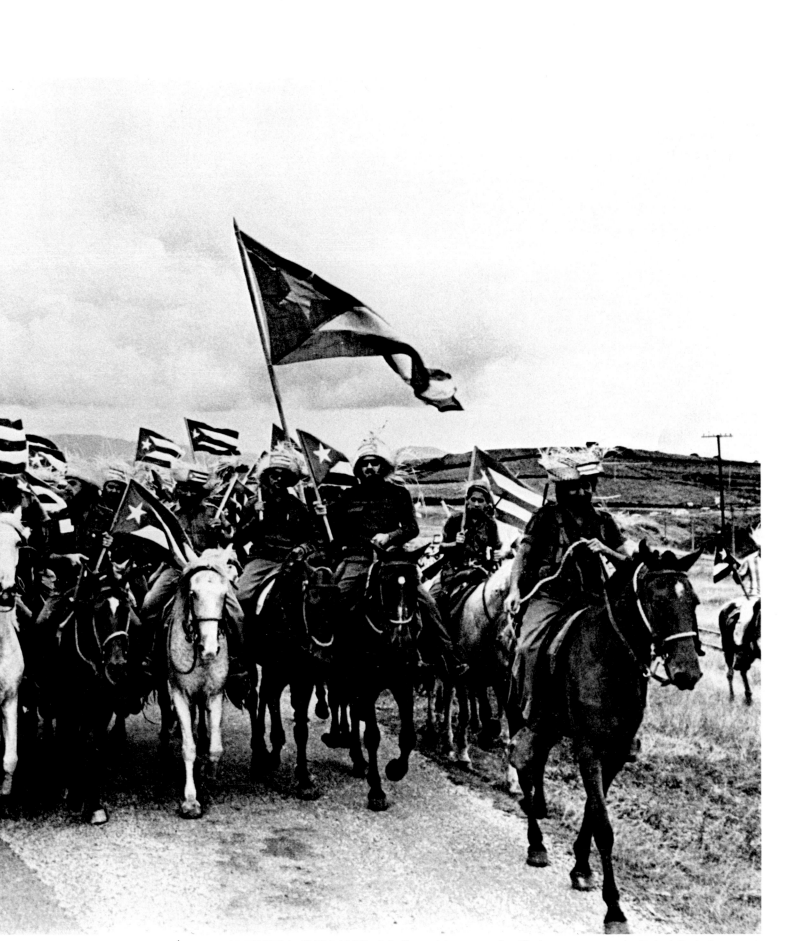

RAÚL CORRAL VARELA (CORRALES), Caballeros, May 1959. Guerilla horsemen enter the United Fruit Company's plantation to symbolically re-enact the takeover of a plantation during the 1895 War of Independence.

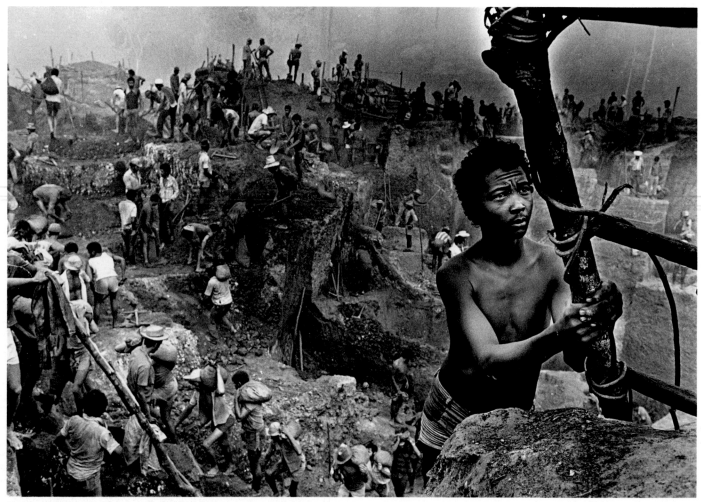

JUCA MARTINS, The Search for Gold, Brazil, date unknown

with advances in advertising photography, which is often more cleanly composed, more lively, better lit, and even more self-consciously photographic than most editorial photography has been. It allows the publication both to compete with the impact of the commercial imagery and to create a good visual environment for advertising, and at the same time to project a safe, palatable image for itself.

Much of conventional journalistic photography is diminished, both by its association in the same publication with imagery of increasing artificiality and by its comparable lack of visual flair, since it is constrained by the often awkward and haphazard quality of the circumstances it depicts. As a result, many publicatons are abandoning traditional photojournalistic practices. A successful bank president, for example, might once have been portrayed sitting at his desk or doing his job, but now many magazines would be delighted if he could be shown tossing money into the air, an image which serves to entertain if not illuminate.

Other than the stalking of celebrities, war photography may be the last arena of human events considered exciting enough for magazines to cover directly. War is an example of what Wilson Hicks called a "self-contained and well-paced drama" whose "crises come put up in handy packages," a situation where there "is neither time nor need for the photographer to direct the people involved in them."

Nowadays, publications tend to glean from major conflicts and tragedies imagery that is vividly sensational without attempting to probe specific cases or decipher root causes. Homeless people, for example, are left safely distant in their tragic poses, and the complexity of the Third World is reduced to violence and poverty. The kind of photojournalistic imagery that so stunned during Vietnam—the photograph of a Viet Cong prisoner being shot in the head, a napalmed girl running in agony, a Buddhist monk aflame in a suicide-protest, a young woman kneeling in apparent grief and shock over a body at Kent State—is milked for its realism but is often published as a kind of decontextualized voyeurism. *Life*'s newest feature, "Newsbeat," for example, is just such a "greatest hits" approach to images that are primarily connected by a high level of visual excitement. *Newlook*, a French periodical published by a recent publisher of *Look*, the influential picture magazine, alternates pictorials on nude women with photojournalistic-style coverage of feature stories, leaving the reader to wonder if either kind of story has any truth to it.

In this context, photojournalism becomes a high-pitched per-

formance for the eyes, disconnected from the intellect and the emotions. Photography's valuable currency as an almost transparent window onto the world is devalued by increasingly obvious manipulation and sensationalism. Furthermore, the rapid disappearance of the picture essay, a form that allows photographers to develop a sustained and deepening narrative while establishing their own point of view, aids in the decontextualization of photojournalistic imagery and in its loss of integrity and strength.

It is illuminating to compare photojournalism's evolution in the United States with the work of photographers in less developed lands, where financial resources and technical sophistication are relatively scarce. In November of 1984, for example, the Third Colloquium on Latin American photography was hosted in Havana. (The first two conferences had been in Mexico City, and the fourth is tentatively scheduled for 1986 in Brazil.) An estimated 400 or 500 delegates attended, mostly from Latin America but including representation from the United States, Europe, and Australia.

Much of the work shown in Havana had about it a directness, a warmth, and a spirit of inquiry that seemed refreshing and almost anachronistic to a person familiar with many of the recent developments in photography in this country. Although the subject matter of many Latin American photographers is already familiar, the point of view expressed is revelatory. Their quiet, gentle, lyrical approach finds subtle rhythms in the most mundane activities, dignity and texture in poverty's deeper chasms, and appears to locate a mythic, ephemeral, entwining presence that outsiders have missed. Work by foreigners, often faster-paced and glossier, tends to implicitly compare the lives of Latin Americans to people in more developed societies. This is a useful function, a bridge between cultures, but there is a greater richness of information about both external and internal life presented in the work of a resident, if one struggles to enter the many facets of its meanings.

As became clear in Havana, part of the problem in understanding photography's capabilities is the illusion about its universality as a language. The presumption that photography is simply an extension of sight and the world a projection of life in the United States does not always make for helpful readings of photographs.

It is a difficult exercise to attempt to comprehend, for example, photographs from Latin America. While reviewing an exhibition of Cuban photography, I was impressed by a photograph of a young girl formally dressed in a long ruffled gown for her "sweet 15" (see page 49). Standing outdoors by the water and surrounded by ordinary-looking adults and children in shorts, she appeared newly conscious of her role as a young woman and elevated from the crowd of people around her. I viewed the image as sweetly romantic, a celebration of awakening individuality and sexuality. But the Cuban author of the photograph, Marucha, was dismayed by my reaction and pointed out that the photograph is a single image from a series critical of the "sweet 15" ritual, a tradition that predates the

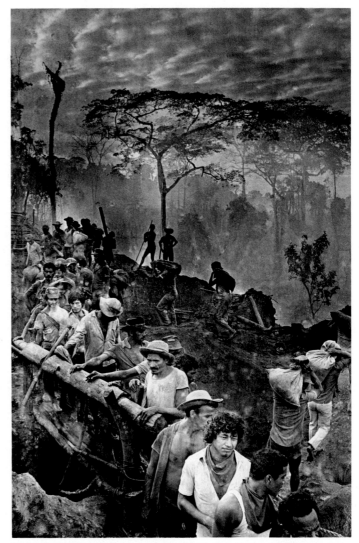

JUCA MARTINS, The Search for Gold, Brazil, date unknown

Cuban revolution and that the photographer considers to be both costly and meaningless. While I have not seen the rest of the series, and this single image may have lost some of its clarity by being shown alone, I was surprised that an image I clearly saw as celebratory was meant as a criticism. By reacting to the image through my own cultural associations, seeing an individual gowned as if in a Hollywood fantasy rising above a banal society, I misread its intent.

Many of the Latin Americans at this conference, as was articulated in the daily lectures and formal and informal discussions, share a desire to explore their own cultural roots and their societies as empathic insiders. A Central American photographer documented the lives of economically impoverished peasants not far from the capital city in order, he said, to increase their reputation in urban society and as a way of elevating their own self-respect. In his work he left out the little bit of modern technology in the village, preferring to concentrate upon the perseverance of their traditional lifestyle. A South American who spent years documenting peasants refused to show any undignified behavior, such as drunkenness, as a protest against negative stereotypes.

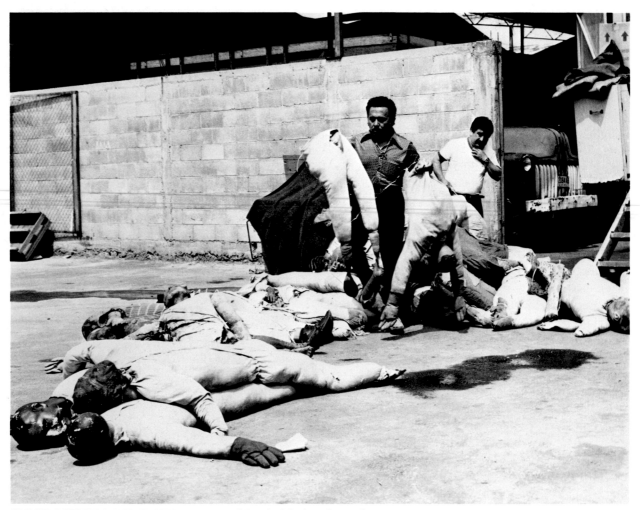

JORGE ACEVEDO MENDOZA, Presence of Death, Mexico, date unknown

Documentary disinterest may be too precious and ineffectual a stance in countries without the same tradition of a free, powerful, and privileged press, especially those whose societies are vulnerable or blatantly oppressed. One much respected Cuban photographer spoke of how in the event of an invasion by the United States he would die happily if he could first shoot a few soldiers, not with a camera but with a gun. The quandary of the U.S. photojournalist in the recent movie *Under Fire* was whether or not to photograph a dead rebel leader as if he were alive to safeguard the Nicaraguan revolution and thereby give up his professional observer status. This might be considered less a question of professional integrity and more one of personal survival were the revolution to have been taking place in his own country.

But it also becomes difficult, arriving in Havana, to sustain a sense of the media in the United States as wholly disinterested. The considerable vitality and successes of Cuban society, the apparent happiness of many of its people, and the ability of a visitor to travel and converse freely in the capital have been largely unreported by a media that over many years has managed to give the impression of Cuba as a kind of gray-colored prison. Perhaps since the media here is often screened by a filter which sees the world according to the strategic interests of the

United States—and tourism and commerce are not at issue due to the economic boycott of Cuba—the positive aspects of life in Havana have been largely ignored.

One's stance as a photographer is also predicated to a certain extent on financial resources. Latin American photographers often cannot afford to make the same kinds of pictures that are made here, even if they desired. Film, paper, and chemicals are often either unavailable or very expensive. One grade or brand of printing paper may be sold for a short while and then disappear, making consistency difficult. In certain parts of Brazil, photographers are said to be able to afford to buy only a sheet or two of printing paper at a time. In Nicaragua, only the smallest piece of paper is sacrificed as a test strip, and then the print is made using a single sheet. In Cuba, a wedding photographer may use one roll of film to photograph several weddings. I saw a professional photographer in Havana carefully pose a young woman in front of a white piano in a restaurant. He made only a single exposure with his 35mm camera rather than attempting several frames in a search for the best expression.

These constraints certainly shape to some extent the development of photography in Latin America, just as the easy availability of the finest photographic supplies affects the kinds of

48

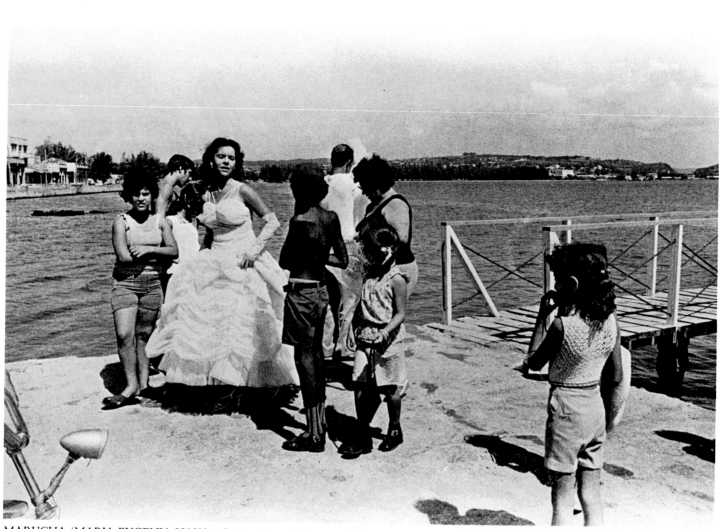

MARUCHA (MARIA EUGENIA HAYA), Quinceañera, Matanzas, Cuba, 1980

images made here. For example, the celebration of one of the more revered schools of photography in Europe and the United States, that of the "decisive moment," may require both a psyche attuned to the rapid changes emblematic of post-industrial societies and enough affluence to produce the many images needed to find the one frame that successfully captures the image. It is difficult in poor societies to "waste" film in experimentation, as photographers are encouraged to do here. It is also more difficult to accord photographs the status of prized objects, made to be looked at as well as looked through, since sophisticated prints are relatively scarce.

It is invigorating and reassuring to see photographs that are simply made and emerge from apparently genuine concerns. But at the same time, in the United States, the fraying cord which has so far safely connected photography and reality is in danger of being completely undone. The computer, which has already revolutionized so much of United States culture, may soon also transform photographs when its ability to generate photographic images without using a camera is perfected. Even now, for example, researchers have mathematically created a virtually photographic image that appears blurred as if stopped in motion by the shutter of a camera. It is predicted that within a decade it will be possible for a computer to generate moving

images of dead actors which can then star in new movies.

Sophisticated computers are already being used in the layout and production of major publications to retouch existing photographs more quickly, easily, and seamlessly than ever before. Once the photographs are digitized, colors can be changed almost immediately, different images composited together in minutes, and elements within a single image subtracted or moved around. On a recent *National Geographic* cover, a computer has been used to move one of the Great Pyramids of Giza so that the photograph is now seen as if from another perspective. Recently, *Rolling Stone* magazine, in pursuit of a less violent cover image, used a computer to remove a shoulder holster and gun from one of the stars of the television show *Miami Vice*.

Electronic cameras which require no permanent negatives or chromes, just a record of electronic impulses on a disc that can be easily erased or modified, are being tested by Japanese newspaper photographers. Their eventual introduction carries with it the potential of exacerbating the problem of journalistic reliability. There is even talk of a new video camera that allows the editor back in the newsroom to monitor what the photographer is seeing through the viewfinder and to select the image from his desk. These new technologies, as they come into being,

49

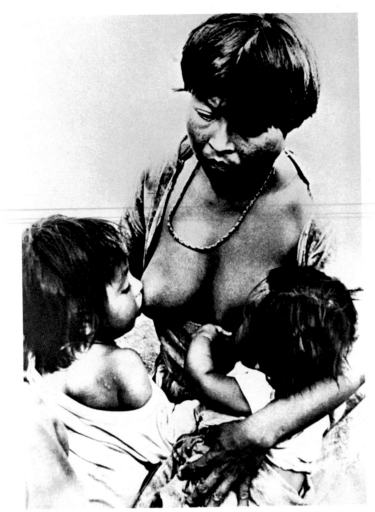

ENSO VILLAPAREDES, from the series "Venezuelan Indians," Venezuela, 1984

question both the documentary reliability on which photojournalism rests and the role of the photographer as intelligent observer. Computer-generated imagery may make it mandatory to label photographic images as fiction or non-fiction, and diminish the public's easy confidence in the realism of photography. Simply holding a piece of paper that has on it what appears to be a photograph might no longer even imply that an event has occurred. Just as photography usurped some of painting's role when it came into existence, so too the computer may cause photography to seem anachronistic, a labored way of reproducing reality.

In the future, if one's pictures aren't good enough, the answer may not be that one is not close enough, as Robert Capa averred, but that one needs to study more mathematics.

While it seems necessary to protect the public confidence in photojournalism's reliability, it is impossible at this stage of the medium's development to revert to the comparative innocence of previous work done in this country or emulate work currently being done in Latin America. Instead, it is increasingly urgent that we begin a redefinition and exploration of the medium and

its applicability to a variety of less traditional forums, including books, walls, audio-visuals and electronic journals. Work is being done at the Massachusetts Institute of Technology, for example, on an interactive electronic journal that will allow readers not only to select the types of news they want to receive over their personal computers but to redesign the format in which it appears, including the number of photographs. Perhaps this system will help create a new market for sophisticated photojournalism, allowing a diversity of approaches.

Rather than try to re-create what is considered the glory days of photojournalism, embodied by the original *Life* magazine and other mass-market magazines and newspapers, it might be wise to extend our concept of the medium. The French daily newspaper *Libération* is a current leader in innovative use of photography. Among many features, it has published, in its foreign-affairs section, a series of photographs taken by Raymond Depardon of his experience of New York during one summer, accompanied by his diarylike text. Sophie Ristelhueber in her recent book depicted the ruin of Beirut using a convention of art photography, the cityscape. Linn Underhill's *Thirty Five Years/One Week*, an impressionistic, almost novelistic account of the death of her sister from cancer, may be considered a highly personal form of photojournalism. By embracing the conventions of the diary, of art photography and even the novel, these works go beyond mere repetition of photojournalism's classics.

Photojournalism's credibility is being threatened and its vitality is waning. Perhaps it is only in a slump. More likely it is in need of a partial overhaul that will preserve what is effective and authentic and expand its range to engage the world and the viewer in ways that take fuller advantage of its capacity for integrity, directness, ambiguity, and intelligence, as well as to transmit masses of information. Otherwise, it may desiccate and become irrelevant, overtaken by more entertaining forms.

DANIEL RODRIGUEZ, Soup Kitchen, Argentina, date unknown

Fidel Castro

Colloquium on Latin American Photography, Havana, 1984

It was my sixth day in Cuba, and midweek of the colloquium on Latin American photography I was there to attend. Joined in informal conversation with delegates from Cuba and the United States in a hallway near the conference room, I looked up to see two men in khaki uniforms going by, one short and clean-shaven, the other tall and bearded. I thought to myself that it's interesting that in Havana soldiers would try to look like Fidel Castro when one of the Cubans in my group turned around, grabbed his camera, and ran after him. It was Fidel.

Soon he was mobbed by delegates with cameras and spoke with individuals. I was impressed that when he spoke to people he appeared to listen to what they were saying. Pedro Meyer, a conference organizer from Mexico, invited him to speak to the delegates from the podium. And a few hours later Castro reappeared. He had just spoken to a women's conference, and now spoke spontaneously for more than an hour and a half about photography, and about health care and baseball and video cassettes and other subjects, quickly moving back and forth from one to the other. During his talk, almost no one moved; a large group of photographers remained standing in the front of the hall.

At the end of his talk, Fidel Castro greeted Manuel Alvarez Bravo, considered Latin America's greatest photographer, who had not lectured but sat through the conference like any other delegate. For many delegates it was a major historical moment— Latin America's greatest photographer being presented to the man whom many consider its greatest politician.

The following text is an excerpt from Castro's speech.

—FRED RITCHIN

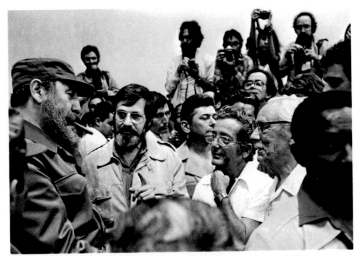

PABLO ORTIZ MONASTERIO, from left to right: Fidel Castro, Pedro Meyer, Raúl Corral Varela (Corrales), and Manuel Alvarez Bravo at the Colloquium on Photography, Havana, Cuba, 1984

Maybe a photograph can't picture an idea. Maybe a painter can picture ideas, maybe abstract painters are trying to express some of these ideas. Well, we're not against abstract painting at all; I wouldn't like you to get that impression. We follow no dogma for art appreciation. But I have seen many books of Cuban photography containing nothing but pictures. There is a recently printed book called *Twenty-five Years Under Revolution*, designed with only photographs. It is wonderful, it has immense value for us. Even if it is difficult to picture an idea, a crowd that sustains its fight for an idea eventually achieves it.

We are very sorry that we didn't have a photographer with us during the revolutionary war or during the first years of struggle, while we were underground, or during the advance to Moncada. We should have taken some photographs but we didn't think about it. There are a few pictures of those days, but there should have been more. We would now be able to write the history of our revolution with those pictures alone.

Unbelievable as it may sound, we have no pictures from when we were on board the *Gramma*, not one. We would have loved it if only an amateur had photographed us. Even Che, who was an amateur photographer and liked to try almost everything, didn't have a camera with him at the time. If only we had a camera with us that day on the *Gramma*, maybe we would now have photographs of the *compañeros*, of the thrilling moments, of the disembarkment, and of all the revolutionary war. Now, after almost 30 years, you feel sadness and regret for not carrying a camera with which you could have taken the pictures that would now speak for themselves. On those occasions, as on so many others, it is only after time passes that people realize that they have been through historical moments that will never be repeated, and that the memory fades. We are not so pretentious as to think that people will talk about us 60 years from now, but at least our relatives and descendants will have some interest in knowing what really happened during those years. We must preserve these moments through photography.

Time passes so quickly and the world changes so much within a short time that we ought to be conscious of the things we do, to make them as good as possible, so future generations will not think badly of us. At least we have the duty to leave a

testimony about how we spent our time. Sometimes one regrets that photography was such a recent invention. When was photography invented? 1839? What a delay for man to discover such an interesting activity!

One of the weapons imperialism uses to defend itself is lying and abusing the ignorance of the people. People have been conditioned for years, and imperialism has used all kinds of sources for conditioning: TV, radio, movies, magazines, and newspapers. If you analyze the importance of TV in the Western world, you will realize that it is in the hands of the most conservative and reactionary people in the world; likewise the news industry that contrives the news. Almost every agency, with the exception of the more trustworthy few, are in the hands of multinational enterprises. These are the people who manage the world news and give us the picture they want.

I remember that when Sadat was assassinated, an American network was able to show the assassination at almost the same time that it was happening. The networks are technically fabulous, because they now have satellites. The underdeveloped countries have nothing of the sort, because they don't have the resources. These networks could become terrible weapons against the nations that are fighting for their independence, because the multinational networks are now more conscious of the importance of information and are scientifically obstructing revolution and real progress. Photography fortunately is not the work of these multinational networks of information. Fortunately photography is the work of an individual. The photographer is able to work with small resources, and it is hard to control photographers. I met Eddie Adams, the American photographer famous for the photograph of the execution of the Vietnamese prisoner. He was here once to report on Cuba. That photograph shocked the world, and he told me how the shock registered. He said that later analysis revealed that at the moment of the photograph, the bullet was neither in the gun nor had it yet gone through the guy's head. The bullet was still in the head of the Vietnamese prisoner. He told me that he was only there by accident, he just happened to be passing. There is always an imbecile who thinks he is doing something great and wants to be photographed. Anyway, Adams said that it was not a great job, it did not require extraordinary resources, like those necessary for TV or films, although I believe that for a good reporter it should not be too difficult to try and work through TV and film. The point is that the role of photography is very important for the development of progressive ideas and for the struggle of the poor nations of the world.

RAÚL CORRAL VARELA (CORRALES), The First Declaration of Havana, Cuba, September 2, 1960

Movie—Television—News—History, June 21, 1979

By Sarah Charlesworth

ps there is no story in the end—but only stories. Various
nts, documents, testimonies assembled by the author who
essly attempts to construct the appearance of an event.
f living time this author again and again must select the
ent, the instant, the single image, word, or object which
verify an absent world—signifying an occurence other
hat which is the present story of its making. And yet this
illusion. Here we have a narrative—the story of a life
even in its passing carries with it the power to effect, to
orm that about which it only sought to speak. The author
es but the account goes on meaning—perhaps something
she did not even quite intend. We are left in the end with
ore than an obscure tale, a play however in which we
gly or unwittingly enact a part. This is real time, it is

inclusive:
available U.S. newspapers, June 21, 1979
all pages photographically depicting the killing
 of ABC newsman Bill Stewart
all photographs of Bill Stewart on included pages
all captions accompanying included photographs
all mastheads, dates, and page numbers

exclusive:
all other newspapers
all other pages
all other text

The five photopieces included in this portfolio have been selected from

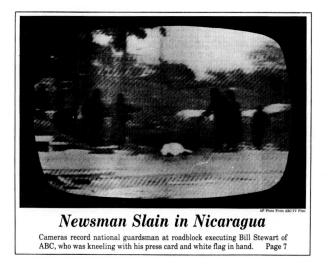

AP Photo From ABC-TV Film

Newsman Slain in Nicaragua

Cameras record national guardsman at roadblock executing Bill Stewart of
ABC, who was kneeling with his press card and white flag in hand. Page 7

Thursday
June 21, 1979

Houston Chronicle

Houston's Family Newspaper

Home
edition

Vol. 78 No. 251 25 Cents Houston. Texas 77002 c Houston Chronicle Publishing Company, 1979

UPI Telephotos
In the left photo, ABC correspondent Bill Stewart, 37, kneels with his arms outstretched as ordered by Nicaraguan National Guardsmen at a roadblock in Managua Wednesday. Next the guardsmen ordered Stewart onto his stomach in the road. Then one kicked him. In the right photo, a guardsman fires a bullet into Stewart's head, killing him. The photos have been reproduced from video tape.

Los Angeles Times

CIRCULATION: 1,057,611 DAILY / 1,344,660 SUNDAY THURSDAY, JUNE 21, 1979 CC/180 PAGES/ Copyright 1979 Los Angeles Times / DAILY 25c

CORRESPONDENT SLAIN—Newsman Bill Stewart lies down on street in Managua under orders of national guardsmen at a roadblock. Seconds later, below, a guardsman shoots him.

AP Wirephotos via ABC News

Daily Press

A

Hampton Roads Morning Newspaper **TWENTY CENTS**

Death Of A Newsman

ABC television news correspondent Bill Stewart was shot to death by a Nicaraguan national guardsman at a roadblock in Managua Wednesday and President Carter condemned the killing as "an act of barbarism." In this sequence of pictures taken from television newscasts, Stewart is shown during an interview before the shooting, left. In the middle photo, he lies down in a street in front of a roadblock as a national guard trooper approaches. Moments later, in photo at right, a guardsman shoots him. See Page 7. (AP)

● *The above photos from a TV screen show how ABC News correspondent Bill Stewart was shot and killed by a Nicaraguan National Guardsman yesterday.*
● *At top left, he kneels down as ordered, holding a white flag and a Nicaraguan press card. Top right, he is ordered to lie on his stomach.*
● *At bottom left, he is kicked by a guardsman; and, at bottom right, the guardsman backs off a few feet and prepares to shoot him in the head.*

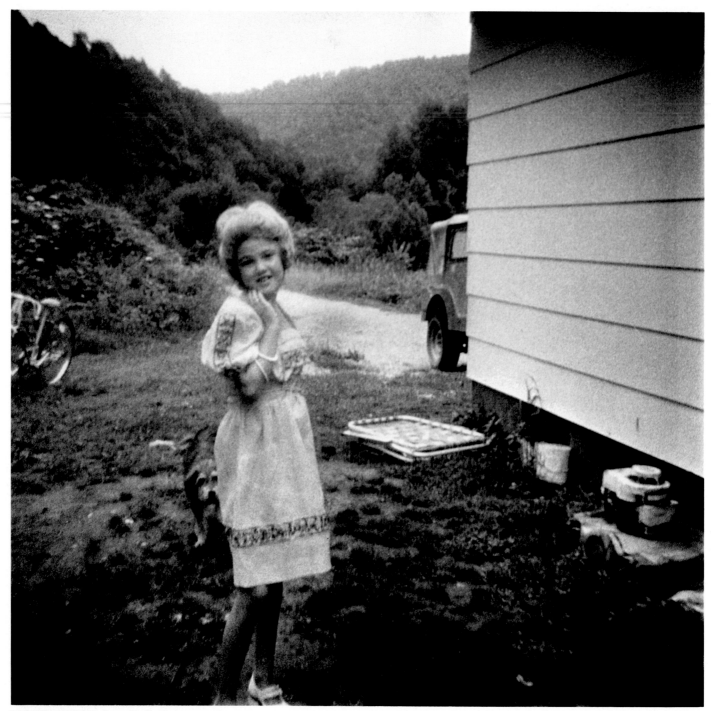

DENISE DIXON, I am Dolly Parton.

To be a child is not an affair of how old one is. "Child" like "angel" is a concept, a realm of possible being. Many children have never been allowed to stray into childhood. Sometimes I dream at last of becoming a child.

A child can be an artist, he can be a poet. But can a child be a banker? It is in such an affair as running a bank or managing a store or directing a war that adulthood counts, an experienced mind. It is in the world of these pursuits that "experience" counts. One, two, three, times divided by. The secret of genius lies in this: that here experience is not made to count. Where experience knows nothing of counting, it creates only itself out of itself.

ROBERT DUNCAN, *On Children, Art and Love*

Dream Portraits

These photographs are by children from remote Appalachian communities in Kentucky. They are the result of the guidance of Wendy Ewald, a young teacher who lived at Ingrams Creek, Kentucky, from 1975 until 1981, while teaching photography classes in three elementary schools. She built darkrooms and gave the children Instamatic cameras. Photography became part of the children's lives in the small communities which revolved around the coal mines, hunting, and the seasonal cycle. Wendy Ewald's encouragement resulted in an extraordinary document of Kentucky life seen through the eyes of children. The language of their dreams emerged. Dream pictures and dream texts included images of visitors from outer space and of death. The work presents a child's view of adulthood which is both fantastic and tragic.—Ed.

I LIKE TO TAKE PICTURES FROM MY DREAMS, from television, or just from my imagination. I like those kind of pictures because they're scary. If I didn't know how I took them, I'd be scared by them. My twin brothers, Phillip and Jamie, pose for me. Sometimes they're good at having their pictures taken, but they get tired of it.

I made a long dream with Phillip and Jamie which comes from TV shows I've watched. I told Jamie to lay down and then put all this makeup on him to make scars and scratches on his mouth down through his nose and on his hands. I put wood on top of him like a house fell on him, and I told him to act like he was dead. I took some in the graveyard above my house. For one I told Jamie to grab a hold of the gravestone and start screaming. For the other I told him to bow down like he was sad. I took the picture from the foot of the grave that had just been filled.

I always think about what I'm going to do before I take the picture. I have taken pictures of myself as Dolly Parton and Marilyn Monroe, and then there was the girl with the snake around her neck. She was supposed to be a movie star, but really it was me. For some I was dancing in my bathing suit while the music was playing in the basement. I told my girlfriend, Michelle, how far to stand and to take the pictures when I said. I like people in action, and I always look for a certain time to take a picture.

DENISE DIXON

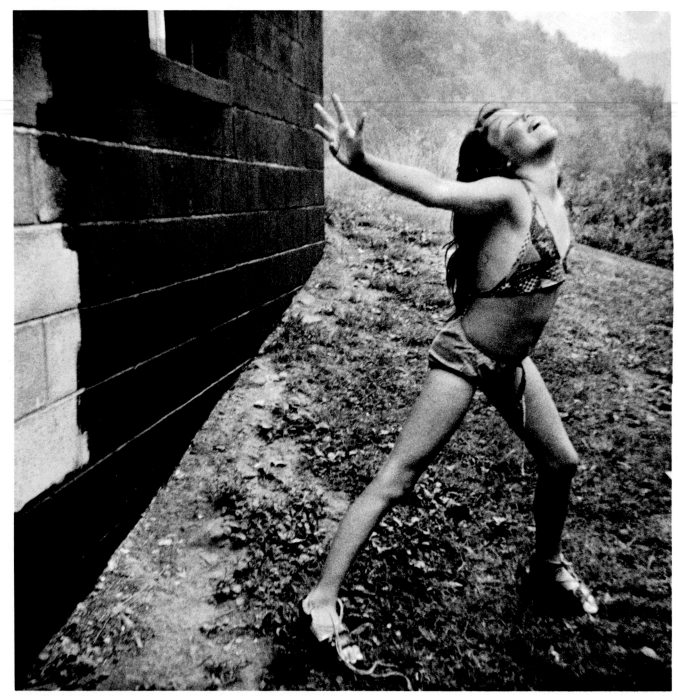

DENISE DIXON, Self-portrait reaching for the Red Star Sky

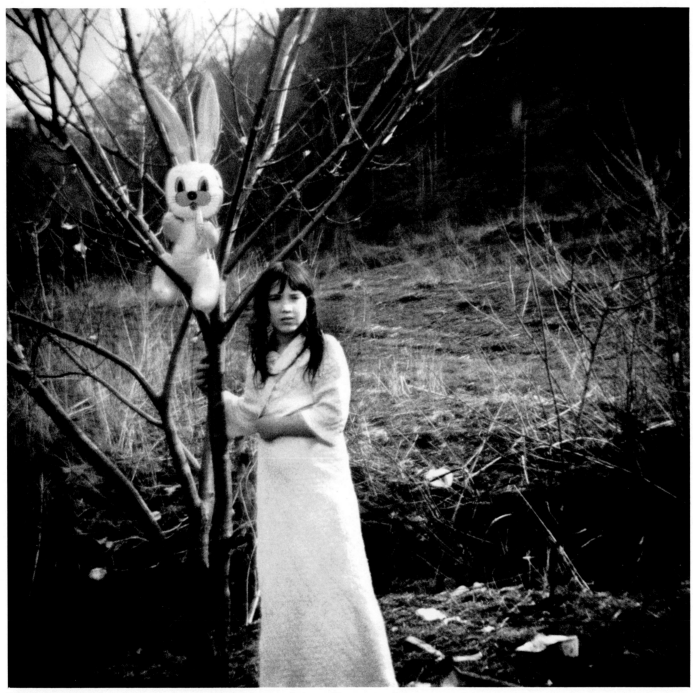

RUBY CORNETT, I asked my sister to take a picture of me on Easter morning.

ALLEN SHEPHERD, I dreamt I killed my best friend, Ricky Dixon.

DENISE DIXON, Phillip and Jamie are creatures from outer space.

*To dream some of the dreams I've dreamed my mind has to be five or six times as big as the world.
There are different places in my mind. Just all over space, earth, everywhere something needs to be
straightened out. And it's just full of a bunch of machines making it go.* DARLENE WATTS

Representation is not a singular act but a continuous and repetitive process of symbolization, a dense and hierarchical vocabulary of the world once removed. "Reality" is increasingly the vanishing point of its image, the inaccessible "other" and "elsewhere" of a copious landscape of articulated separation. . .

. . . The entry into an image, the rupture and reintegration of its coherent form, exposes that which lies between meaning, the reciprocal meeting of an object and its apprehension.

SARAH CHARLESWORTH

We like to imagine the future as a place where people loved abstraction before they encountered sentimentality.

SHERRIE LEVINE

SARAH CHARLESWORTH, Spiral Galaxy MGC 4565 (photo-mural print, original size 67x50), 1981

CLARENCE JOHN LAUGHLIN, Reality as a Stage Set, 1965

The mystery of time, the magic of light, the enigma of reality—and their interrelationships—are my constant themes and preoccupations. Because of these metaphysical and poetic preoccupations, I frequently attempt to show in my work, in various ways, the unreality of the "real" and the reality of the "unreal." This may result, at times, in some disturbing effects. But art should be disturbing; it should make us both think and feel; it should infect the subconscious as well as the conscious mind; it should never allow complacency nor condone the status quo.

My central position, therefore, is one of extreme romanticism—the concept of "reality" as being, innately, mystery and magic; the intuitive awareness of the power of the "unknown"—which human beings are afraid to realize, and which none of their religious and intellectual systems can really take into account. This romanticism revolves upon the feeling that the world is far stranger than we think; that the "reality" we think we know is only a small part of a "total reality;" and that the human imagination is the key to this hidden, and more inclusive, "reality."

CLARENCE JOHN LAUGHLIN, *The Personal Eye*

Poe, in Ligeia, quotes Bacon: "There is no exquisite beauty without some strangeness in the proportion." This, at last, is the final rallying cry of the Romantics. Mae West, oracular to the end, would dare to say it a little too amusingly to suit Clarence, when she says to her dwarf: "Honey, you ain't seen nuthin' yet!" Where the Lady stops, nobody knows. Give Clarence John Laughlin an object—the chances are exactly the same. It's a brand-new ball game, fans, and we're going into extra innings . . .

JONATHAN WILLIAMS

People and Ideas

CLARENCE JOHN LAUGHLIN
(1905–1985)

Influenced by Baudelaire and the French symbolists, Clarence John Laughlin challenged purist conceptions of photography. He evoked a Romantic, almost supernatural Southern world through double exposures, multiple printing, constructed stage sets, and collage. Believing that "the physical object is merely a stepping stone to an inner world," Laughlin investigated the ambiguous division between the real and the unreal.

Laughlin was born in Louisiana in 1905 and began photographing in 1934. In his professional career he worked in the civil service, was a fashion photographer for *Vogue*, a member of the photography department of the National Archives in Washington, DC, and an associate of research at the University of Kentucky.

Michael P. Smith, *Clarence John Laughlin*

Photographing the architecture, statues, columns and other antiquities of the Old South, Laughlin explored the qualities of time and decay. He believed in the power of the imagination to understand an elusive reality. By animating material objects, he ultimately rejected a mundane material life and expressed his highly personal vision of a world beyond ordinary perception. This exploration he envisioned as the responsibility of modern photography.

AN EXPERIMENT WITH CONSTANTS
A Review of *Unknown Territory*: *Photographs by Ray K. Metzker*
by Michael Berryhill

In a letter to one of his students about looking at photographs, Ray Metzker advised: "Look for the constants. Often you will see that they are obvious and simple. Then look for the way these constants have been worked, combined, added, and subtracted. Finally, consider the different meanings that result. Along the way we discover how some small decision, a different attitude, maybe even an intrusion, adds a whole new dimension."

Metzker was referring to the work of other photographers, but he was writing about himself. For the last 30 years he has been experimenting with his constants in superb black-and-white photographs of great formal clarity and innovation. They create sadness and "tenderness," to use one of his favorite words. Until the opening of his first major retrospective at Houston's Museum of Fine Arts last December, it was not possible to see just how constant Metzker has been in his vision. Despite numerous

exhibitions and the publication of two books of his photographs, Metzker has remained relatively obscure. *Unknown Territory*, a retrospective of works from 1957 to 1983, will make Metzker better known.

Metzker is a poet, and the poet he most resembles is Emily Dickinson, who wrote: "After great pain, a formal feeling comes. . . ." Like many poets he has been conditioned by solitude, channeling his expressiveness into the formality of art. Metzker grew up in a suburb of Milwaukee. His parents were preoccupied with the care of his older sister, who was stricken with cerebral palsy. Their focus on the sister increased his isolation. Metzker describes himself as acutely shy in his youth. Photography gave him a connection, a way of formally encountering the world and expressing his love for it, or what he calls his belief "about the goodness of things."

Like many artists, Metzker converted an emotional handicap into a strength. His photographs suggest his early shyness in the way they avoid faces. In one picture of a wall in Albuquerque, he shows a poster of a face that has been torn away except for an eye. It serves as a commentary on his own work, an inside joke.

Faces are the most obvious tools of social intercourse. We teach children to overcome shyness by learning to look directly in the face of an adult. We measure each other by faces, communicate with them, express our dramas with them.

Metzker is interested in nothing so direct. It is as though he cannot bear the direct stare of someone, even though he has the camera as a kind of shield between him and the subject.

Metzker is not interested in story; he is interested in his lyric vision of people

caught in unfocused and solitary moments. The gazes of his characters, when their faces can be seen, seldom intersect. In a picture from his series "Chicago, 1959," a sailor appears to be looking down at his feet, but he is lost in thought. Next to him, a woman in a white blouse and dark skirt is staring with worry at something beyond the picture frame. The girl next to her is looking out at something else altogether and is licking her lips. Behind her, a woman moves her mouth slightly, making a grimace. The man next to her reads intently from a rolled-up newspaper or magazine. To his right, another man in a straw hat seems to be looking past the girl in the ruffled petticoat and whistling to himself. Behind

It's a moment in ordinary time, a non-dramatic moment, but a moment so complex that the viewer wanders and wanders in the multiplicity of its worlds. The sailor will shift his weight and straighten his trouser leg, the man will stop whistling, the bus they appear to be waiting for will come. Each is lost in a private world of consciousness. Each is shy. Each is the photographer.

Metzker says that the camera confers value on the world, that every person is a hero, and here he resembles Walt Whitman more than Emily Dickinson. The poet photographer's task is not to tell stories but to capture ineffable moments that unite us.

We are commonly trapped in a world

not of decisive moments but of ignored moments, ignored places, ignored people.

He does this with juxtapositions. A woman in a train who is startled at seeing him (one of the few direct gazes in his work) looks with wide white eyes at the intruding, interrupting camera. The spheres of her eyes are echoed in the mechanical regularity of the rivets in the train. A man behind her, visually separated by a window, is about to blow or has blown his nose with a crumpled handerchief. Crumpled whiteness pops up again and again in his pictures (finally dominating the foreground in his "Pictus Interruptus" series). Made in 1959, this picture is, in a sense, Metzker's first "Couplet," a poetic term he uses for the

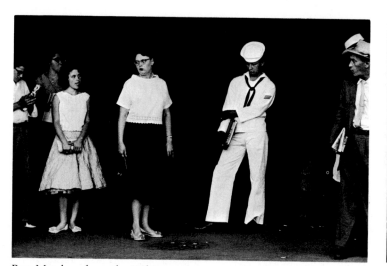
Ray Metzker, from the "Chicago, 1957-1959" series

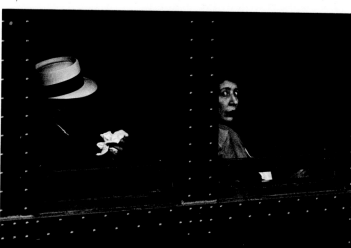
Ray Metzker, from the "Chicago, 1957-1959" series

him, we see the top of a light hat and a dark hatband. (Hats and eyeglasses are frequent motifs in Metzker's pictures, interrupting the face.) The composition is divided in the middle by a receding darkness. The sailor tends to dominate the frame because he is dressed in white; his black neckerchief and the three black stripes on his upper sleeve are abstracted. He is standing with his weight on one leg, like a classical nude statue. The bottom of one trouser leg is caught on the top of his shoe, and the viewer becomes acutely aware of some small pieces of cigarette butts on the sidewalk.

of comings and goings, of waiting and standing and thinking. That is the essence of Metzker's first student work produced at Chicago's Institute of Design, and that is the theme of his more recent work, "City Whispers." Here we are, Metzker seems to be saying, with our purses and valises and newspapers and paper sacks, dressed in our uniforms and eyeglasses and hats, running our errands, walking to our jobs, living lives that are, as the world conventionally considers things, insignificant. Metzker interrupts that convention and tries to make us see afresh. He makes us feel the significance

dual-negative prints he further developed in the late '60s. The juxtaposition of two prints forces the viewer to interpret the relationship of the two images.

In one "Couplet," for example, we see a baby in diapers, his face and body completely in shadow. The picture invites us to imagine the gaze of the child. The viewer fills in, completes the image, with the detail the photographer has left out. By itself, the picture is not nearly as compelling as when it is placed next to that of an adult man, also in shadow, his face obscured. He stands with legs slightly apart, echoing the stance of the baby. He

stands between the kind of sawhorses that are used in New York to block off traffic for parades. (Part of Metzker's early work is a series of pictures of people watching parades.) The baby seems newly upright, independent, an incipient man with the symbol of his babyhood, his bottle, on a blanket. The adult is caught between the sawhorses as in a pair of pincers, symbols of the entrapment of work and death. Their faces are not visible because Metzker is interested in their stances, not their expressions. By obliterating faces, he compels us to see their stances as vulnerable and courageous. Every loss is a gain.

Some of Metzker's most compelling works are in the "Pictus Interruptus" se-

mother and daughter walking down the steps of their house. Their faces are obscured by tree branches in the foreground. The adult and child are relaxed, alive, about to go on an errand, tender; but the blurred leaves give the picture a smell of mortality.

One of Metzker's most touching series is "Sand Creatures, Atlantic City, 1975"—pictures of people at the beach. Their bodies are not conventionally beautiful, and their faces are frequently locked in thought. The faces of people sleeping are relaxed, a disturbing reminder of death. At the beach, Metzker finds us vulnerable, fragile, imperfect. It is Metzker at his tenderest, without ever being sentimental.

simplicity and tenderness. Such are the constants of Ray Metzker.

The exhibition *Unknown Territory: Photographs by Ray K. Metzker*, organized by The Museum of Fine Arts, Houston, will be shown at Philadelphia Museum of Art from October 19, 1985 until January 5, 1986, The High Museum of Art, Atlanta from March 22 until May 4, 1986, International Museum of Photography, The George Eastman House, Rochester, New York, from June 6 until August 10, 1986 and the National Museum of American Art, Smithsonian Institution, Washington, D.C. from September 12 until November 23, 1986.
Unknown Territory, Photographs by Ray K. Metzker was published by Aperture, New York, 1984, $25.

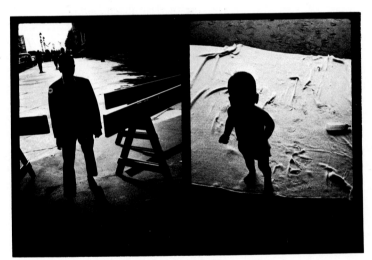

Ray Metzker, *Atlantic City/New York City*, 1968

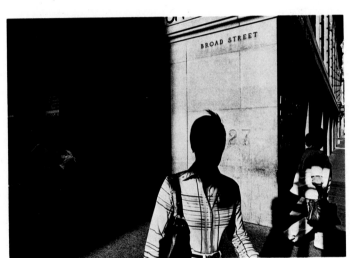

Ray Metzker, from "City Whispers: 1980-1983" series

ries. Here he interrupts the picture frame with some common object thrust before the camera lens, destroying and remaking the composition, forcing the viewer to strain through the distraction. Metzker abhors the picturesque. To be picturesque would be to involve himself with the crowd, to betray his personal vision. The "Pictus Interruptus" series is a different form of juxtaposition, a jolt to the viewer's sensibility. Metzker explores the edges of abstraction, but his empty landscapes have a curiously melancholy and human dimension. The technique was foreshadowed in work such as that of a

Another delight of the exhibition is the large, one-of-a-kind composites that Metzker creates by repeating a print or a series of prints. "Spruce Street Boogie," for example, uses a variety of pictures made as people walk into a sun-filled staircase. Each separate picture includes the same elements, but each image is slightly different. Metzker stands back and lets the people create the photographs as they move into the frame.

This photograph, like other Metzker experiments with form, does not exist for the sake of form itself, but instead creates an emotional experience with patience,

IN PRAISE OF AGEE
A Review of *James Agee: A Life*
By Danny Lyon

There are few figures as important to American photography as James Agee, which is saying a lot because while Agee was a poet, writer, movie critic, dramatist, and at least once—with Helen Levitt—a filmmaker, he was not a photographer. In his writings, in the introduction to *Let Us Now Praise Famous Men*, in his introduction to Helen Levitt's *A Way of Seeing*, and throughout his film reviews, Agee developed the idea

of realism in photography. He saw the camera as *the* most powerful and important instrument of modern times. He argued that the greatest film would one day be made from the newsreel footage of the Second World War. And he argued that the ability of the camera to take directly from reality was the core of its power. When he teamed up with Walker Evans in 1936 to make a book of tenant farmers in Alabama, this pair of thoroughbreds formed a partnership the likes of which we will probably never see again. Agee was not interested in making a work of art (he claimed) but in bringing something real back to New York and to the Greenwich Village society to which he belonged and which he half despised.

"This is a *book* only by necessity. More seriously, it is an effort in human actuality, in which the reader is no less centrally involved than the authors and those of whom they tell." This attitude of Agee's would guide the making of countless future books and films, creating an aesthetic that would subvert both journalism and filmmaking and to this day, almost 50 years later, has hardly begun to run its course. When Agee lived with Alma Mailman in Frenchtown, New Jersey, they shared the house with a bum who showed up looking for food. Agee and Walker Evans found a trunk of old letters in the attic. Agee saw them as "faultless works of art" and wanted his publisher to rush them into print as another book. He believed that ordinary people have genius.

Billy McCune, who has an official I.Q. of below 90 and was once adjudged by the state of Texas as "feeble minded," would illustrate my book *Conversations with the Dead* from inside his prison cell and through his letters write the text for the same book. Later, using a five-cent Bic refill, he would write his autobiography, which was published by Straight Arrow and Dell. Bill Sanders, a Houston tattoo artist and alcoholic (another alcoholic!) carried the award-winning film *Soc. Sci. 127* with his spontaneous and brilliant diatribes. How is it that people without education, people who never heard of Shakespeare, can speak with the wit, the intelligence, and the presence of

a character in a Shakespeare play? Is it because the inspiration for art has often come from real life and real people; is it that with cameras, for the first time in history, the artist, instead of inventing or re-creating people on paper, could simply go out and film them? Norman Mailer's novel *The Executioner's Song* had more power and more success than many of his previous novels. Almost all of it was based on thousands of hours of tape recordings done with Gary Gilmore, an ex-con and murderer, and his young girlfriend Nicole. *The Executioner's Song* was in fact a brilliant editing job accomplished by probably the only person capable of doing it so well, Norman Mailer the novelist. What Agee realized and said was that the camera had begun a new age, an age in which you didn't have to invent Falstaff, you could go out and find him in a bar.

Agee wanted and almost had *Let Us Now Praise Famous Men* published on newsprint as an official government report. When the book finally did appear, it failed; but when it was published again in 1960, it became the teething ring for a whole generation of American photographers, reporters, writers, and filmmak-

Helen Levitt, *James Agee, New York City,* 1945

ers—and has remained so ever since. Agee succeeded in destroying the separation between himself and the subject, a separation that was painful to him, as much of life was painful to him. After *Let Us Now Praise Famous Men* no one could go back to the old way. I could not have done *The Bikeriders* without having first read *Let Us Now Praise Famous Men*, and I don't see how Danny Seymour's *A Loud Song*, or Larry Clark's *Tulsa*, could have been done without it either. Besides, none of us in the 1960s had any choice: Agee came first and we were his children.

James Agee was as American as corn and it showed in everything he did. He was a romantic who adored reality and had the gifts and stamina to be able to express that adoration. His work was like life, filled with feelings, with rage and with love. When he went to Alabama his empathy with his subject was total.

It is too bad that Laurence Bergreen, the Harvard-educated author who recently published *James Agee: A Life,* "the first full-length biography" of James Agee, didn't have a little more empathy with his subject. But then Bergreen spent so much effort learning the details of James Agee's life, and passing them on to us, that he seems to have missed the importance of James Agee's work. The overwhelming impression that is left by Bergreen is not of Agee's ideas but of James Agee's drinking and extra-marital sex life, something that seems to bother Bergreen. Through the course of the book, Agee's first two marriages fall apart, and he drinks more and more. We get long testimonials from women who befriended Agee and a detailed description of Agee and Evans working together in bed. At this point the biography reads like a copy of the *National Enquirer* that has been certified at Harvard. In fact Bergreen has indexed his work. Under "Agee, compassionate nature of," we find five references; under "Agee, drinking habits of," we find 25. On the same page, under "Agee, extramarital affairs of," we get 29. (That's 29 references, not 29 affairs.)

A biographer can pick and choose among the remnants of a person's life and

Helen Levitt, *James Agee and Delmore Schwartz, New Jersey*, 1939

by choosing give the emphasis that he wants. He is making a creation as much as any picture or film editor does. That Bergreen chooses to devote so much space to Agee breaking glasses in bars and having affairs says more to me about Bergreen than it does about James Agee.

What if Agee had written his own biography? In a way, he did. You learn much more about James Agee in his own writings than you do in Bergreen's. Agee loved the people he wrote about, and he treated them accordingly. Couldn't this man who did so much for us, and at an incredible price to himself, have been treated with just a little of the sympathy that resonates through his own writing? And now the *New York Times Book Review* has run, on its front page, a drawing

of Agee as a bloated drunk and the crack that one of his talents was looking good in photographs! But Agee would have understood it all; he saw the hypocrisy of society, and his life was one long rebellion against it. Somewhere in one of the editions of his work is a song Agee liked: "This world is not my home. I'm only passing through." James Agee passed through like thunder. And maybe down the road lies someone who can tell his story again—someone with more interest in his work and ideas and less interest in exploiting the details of human weakness.

James Agee: A Life, by Laurence Bergreen, is published by E.P. Dutton, New York, 1984, $20.

AGEE AND THE PHOTOGRAPHER'S ART
by Andrew Mossin

In the photograph taken of James Agee in 1945, his face has acquired a sunken softness, a gentleness about the mouth and eyes. His high forehead tilts down; his eyes have sunk back into the shadows of his brow and gaze downward with a quiet, impenetrable regard. His cheeks have become slack about his jawbones; and his hair, once wild and curly, is now brushed back across his head. The picture reveals a moment in which a man rests against a wall and perhaps wonders what he will do next, what he has done so far.

Helen Levitt, a photographer Agee admired greatly and a friend of the writer,

Helen Levitt, *James and Mia Agee*, 1942

took this photograph, along with several others, one summer afternoon. They form a loose portrait of a writer who, nearly ten years before, had struggled to tell in words of the day-to-day existences of three sharecropping families in the Deep South. The signs of that struggle and of the many others since, of the fatigue brought on by the intensity of his living, which was as much a part of him as his boyish charm: all of this is here for us to see in these photographs.

Agee's fascination with film and photography can be traced back to the times when, as a boy, he sat with his father in the darkness of the Knoxville movie theater and watched Charlie Chaplin cavort on the silent screen. Later, Agee would find in the Civil War photographs of Mathew Brady a resonance and clarity of expression he would come to regard as essential to all good photography.

Agee well knew the possibilities of the camera to inform and delight, as well as the ease with which it could be misused. As he would write in his introduction to Helen Levitt's collection of photographs, *A Way of Seeing:*

> It is clear enough by now to most people, that "the camera never lies" *is a foolish saying. Yet it is doubtful whether most people realize how extraordinarily slippery a liar the camera is. The camera is just a machine, which records with impressive and as a rule very cruel faithfulness, precisely what is in the eye, mind, spirit, and skill of its operator to make it record.*

Agee understood the great difficulty each photographer faces in attempting to render truthfully the world outside the camera, which is just as well the world outside each one of us, and the complexity of emotional response, personal interest, and artistic aim on the part of the photographer that can thwart any such attempt and produce an image we cannot trust. The work of each photographer finally "is not to alter the world as the eye sees it into a world of aesthetic reality, but to perceive the aesthetic reality within the actual world, and to make an undisturbed and faithful record of the instant in which this moment of creativeness achieves its most expressive crystallization." Nothing matters, Agee suggests, as much as what occurs in that moment of actually seeing; anything else is a betrayal of the instrument and "a contraceptive on the ability to see."

While every photographer works within the limits of his or her own talents and abilities, the element of luck clearly plays a large role in the process and is "one which a photographer has unique equipment for collaborating with." The sense of "capturing the moment" and all that implies (Agee's reference to the camera as "a stealer of images" comes to mind) creates an aesthetic tension between photographer and subject that informs the image. "The photographer's adventure," Agee writes, is "to know where luck is most likely to lie in the stream, to hook it, and to bring it in without unfair play and without too much subduing it." The question of unfairness poses the dilemma of aesthetic verisimilitude: how does one determine when the photographer (or writer, as in the case of Agee) is intruding on the world he attempts to record (whether for documentary, artistic, or other purposes) and when he is out of the picture as much as possible, relying on the accuracy of the lens to portray the world that "is in its own terms an artist." Agee would wrestle with this issue and much else through the long summer of 1936, when he and Walker Evans traveled to Alabama to live with three tenant-farming families for research on what was to have been an article for *Fortune* magazine and became instead the classic volume *Let Us Now Praise Famous Men.*

The house in Frenchtown, New Jersey, where Agee wrote a major portion of *Let Us Now Praise Famous Men* is still there. It stands next to the old firehouse that is now a police station, and a Baptist church whose glass-enclosed sign announces the times of Sunday school and prayer meetings. Coming here one feels that little has changed in this town on the eastern shore of the Delaware River since 1938, the year Agee and Alma Mailman began living here. It is easy to imagine Agee emerging from their narrow white wood-frame house in the early darkness of morning, after a long night of writing, and walking through the silent residential sidestreets.

In writing *Let Us Now Praise Famous Men*, Agee set himself the most difficult

task of all and one at which he was bound to fail, that of trying to embody in words the embattled lives of the Rickettses, Gudgers, and Woodses, to give his readers the full shape of their day-by-day existences, while recognizing at every step that "words cannot embody; they can only describe." In struggling to go beyond the inherent limits of language, Agee particularizes each detail of the farmers' lives, from the rooms they live in to the land they work on to the tables they eat at to the beds they return to at night.

The great achievement of *Let Us Now Praise Famous Men* is clearly its joining of Evans's photographs, which describe in a way that is both lyrical and laconic, with Agee's text, which holds steadily to a visual center. We feel when we view Evans's photographs that there can be no doubt about what we are seeing, that the people they portray and the rooms these people inhabit are "totally actual." Similarly, Agee's prose moves us to the sensation of exact feeling, as when he describes one of the sharecropper's homes:

> . . . *each texture in the wood, like those of bone, is distinct in the eye as a razor: each nail-head is distinct: each seam and split; and each slight warping; each random knot and knothole: and in each board, as lovely a music as a contour map and unique as a thumbprint, its grain, which was its living strength, and these wild creeks cut stiff across by saws; and moving nearer, the close-laid arcs and shadows even of those tearing wheels: and this, more poor and plain than bone, more naked and noble than sternest Doric, more rich and more variant than watered silk, is the fabric and the stature of a house.*

Over and over, Agee presents us with the observed physical details of these people's lives in a language that is pure, almost translucent at times, and always loving of his subject:

> *He was in dark trousers, black dress shoes, a new-laundered white shirt with lights of bluing in it, and a light yellow, soft straw hat with a broad band of dark flowered cloth and a*

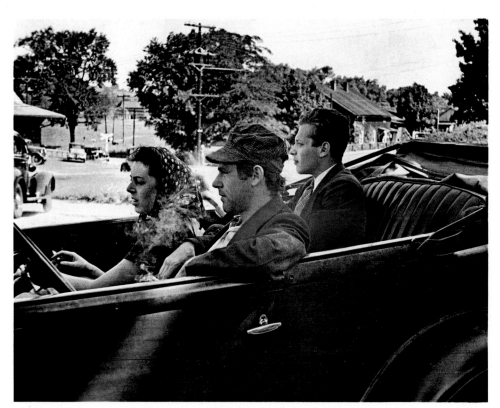

Helen Levitt, *James and Alma Agee with Delmore Schwartz, New Jersey,* 1939

> *daisy in the band; she glossy-legged without stockings, in freshly whited pumps, a flowered pink cotton dress, and a great sun of straw set far back on her head.*

For each singular moment caught in the lens of Evans's camera, so does Agee's own mind function throughout as a lens, transcribing the visual world into verbal images of clarity and light.

Agee's doubts about his ability and even his right to describe the lives before him run throughout the book and form its intellectual center. For as much as *Let Us Now Praise Famous Men* may be said to be about the lives of sharecroppers, it is equally about the continual struggle to convey in words the exact nature of those lives, indeed to bring onto the page the full realm of their reality. "If I could do it," Agee writes in the Preamble, "I'd do no writing at all here. It would be photographs; the rest would be fragments of cloth, bits of cotton, lumps of earth, records of speech, pieces of wood and iron, phials of odors, plates of food and of ex-

crement." The book Agee wrote, which he would describe as "an effort in human actuality," is a heroic attempt to transcend the social, artistic, and personal limits of language and to portray through a new kind of expression (combining philosophy, autobiography, and social commentary) the full beauty, sorrow, and ultimate variousness of the lives Agee and Evans witnessed in their time together.

Almost 50 years after Evans made his photographs and Agee sat with his notebook through the hot Alabama nights, their book remains a powerful invocation and a unique record from a time and a place and of a people that have been long lost to us. We need only look into the eyes of Bud Woods, Fred Ricketts, Annie Mae and George Gudger in the portraits from that time to recognize in the "angry glory" of their stares the full truth of what Agee sought to tell us.

Helen Levitt's book *A Way of Seeing*, with an introduction by James Agee, was republished in 1981 by Horizon Press, 156 Fifth Avenue, New York, $27.50.

CONTRIBUTORS

SARAH CHARLESWORTH's work was included in the Whitney Biennial, 1985. Her most recent individual shows were at the California Museum of Photography in Riverside and the International with Monument gallery in New York City.

ROBERT CUMMING was one of ten photographers commissioned by the Olympic Arts Festival to photograph the 1984 Olympics in Los Angeles.

BRIAN DEPALMA's films include *Scarface*, *Dressed to Kill*, and *Blow Out*, as well as *Body Double*. His latest project, a comedy, *Wise Guys*, was filmed in Newark and Jersey City.

SUSAN DWORKIN, author of *Double DePalma*, is a playwright, a Peabody Award-winning television writer, and author of the film study, *Making Tootsie* (1983).

WENDY EWALD taught photography in elementary schools in Appalachia. In 1981 she received a Fulbright Fellowship to teach photography to children in a Colombian village school. Her publications include *Appalachia: A Self-Portrait*. She is currently writing a film script about the childhood of a Colombian girl. *Portraits and Dreams, Photographs and Stories by Children of the Appalachians* by Wendy Ewald was published this year by Writers and Readers.

DAVID GRAHAM lives and works in Tyler State Park, Newtown, Pennsylvania. His work was part of the "Color Photographs: Recent Acquisitions" exhibition at the Museum of Modern Art in 1984.

NIC NICOSIA's work has been shown at the Akron Museum; the Contemporary Arts Museum, Houston; and the Whitney Biennial, 1983. He is currently working on a series entitled "The Cast" in which he creates character sketches, emphasizing portraiture rather than setting.

RICHARD PRINCE initiated rephotography in New York City in 1977. His work appeared in the Whitney Biennial, 1985. Prince, author of *Why I Go to the Movies Alone*, is now at work on a second novel, *I'm So Excited*.

FRED RITCHIN was picture editor of *The New York Times Magazine* from 1978 to 1982 and served as executive editor of *Camera Arts* magazine. He is currently director of the Photojournalism and Documentary Program at the International Center of Photography in New York and is writing a book on contemporary photojournalism.

DAVID ROBBINS is currently at work on a film about Richard Prince, Sherrie Levine, Louise Lawler, and Allan McCollum called *Controlling Interest*. He has also interviewed William Wegman, Jenny Holzer, Thomas Lawson, the members of SITE, and Keith Haring, and co-edited David Hockney's *Photographs* (1983).

LAURIE SIMMONS's work was exhibited in the Whitney Biennial in 1985. Her most recent one-person show was at the International with Monument gallery in New York in 1984.

HIROSHI SUGIMOTO's photographs have been included in exhibitions at the Museum of Modern Art in New York. His most recent one-person show was at the Sonnabend gallery in New York in 1983.

JOEL-PETER WITKIN's work was selected by Edward Steichen for the exhibition "Great Photographs from the Museum Collection" at the Museum of Modern Art in 1959. In the 1960s, Witkin trained as a combat photographer in the army. His first major museum retrospective exhibition is scheduled for December 1985 at the Museum of Modern Art in San Francisco. His first monograph was published this year by Twelvetrees Press, California. He is currently working on a gravure portfolio.

CREDITS

Inside front cover, pp. 2, 55–59, 67 photopieces by Sarah Charlesworth, courtesy of the artist. Pp. 3–5 photographs by Laurie Simmons, courtesy of the artist. Pp. 6–8, 11 photopieces by Richard Prince, courtesy of Baskerville and Watson, New York. Pp. 14–17 photographs and text by Robert Cumming, courtesy of Castelli Graphics, New York. Pp. 18–19 photographs by Hiroshi Sugimoto, courtesy of the artist. Pp. 20–21 photographs by Lejaren à Hiller, courtesy of Visual Studies Workshop, Rochester, New York. P. 22 photopiece by John Baldessari, courtesy of Sonnabend Gallery, New York. P. 23 photopiece by John Baldessari, from the collection of Ealan J. Wingate, courtesy of Sonnabend Gallery, New York, P. 24 movie still, and p. 25 color etchings by John Baldessari, courtesy of Peter Blum Edition, New York. Pp. 26–27 photographs by Nic Nicosia, courtesy of the artist. Cover, pp. 28–31 photographs by David Graham, courtesy of the artist. Pp. 35, 37–39, 41 photographs by Joel-Peter Witkin, courtesy of Pace/MacGill Gallery, New York. P. 42 photograph by Rubén Cárdenas Paz, courtesy of the photographer. P. 43 photography by Nacho López, courtesy of the photographer. Pp. 44–45 photograph by Raúl Corral Varela (Corrales), courtesy of Ledel Gallery, New York. Pp. 46–47 photographs by Juca Martins, courtesy of Agencia F4. P. 48 photograph by Jorge Acevedo Mendoza, courtesy of the photographer. P. 49 photograph by Maria Eugenia Haya (Marucha), courtesy of Ledel Gallery. P. 50 photograph by Enso Villaparedes, courtesy of the Colloquium on Latin American Photography, Havana, 1984. P. 50 photograph by Daniel Rodriguez, courtesy of the Colloquium on Latin American Photography, Havana, 1984. P. 51 photograph by Pablo Ortiz Monasterio, courtesy of the photographer. Pp. 52–53 photographs by Raúl Corral Varela (Corrales), courtesy of Ledel Gallery. P. 54 photograph courtesy of Associated Press—Wide World Photos, Inc., New York, New York. Pp. 60, 62, 65 photographs by Denise Dixon, courtesy of Wendy Ewald. P. 61 text from "Statements on Poetics," essay by Robert Duncan, appearing in *The New American Poetry*, © 1960, edited by Donald M. Allen, published by Grove Press, Inc., New York, New York, reprinted courtesy of the author. P. 63 photograph by Ruby Cornett, courtesy of Wendy Ewald. P. 64 photograph by Allen Shepherd, courtesy of Wendy Ewald. P. 68 photograph by Clarence John Laughlin, courtesy of the Philadelphia Museum of Art. P. 69 photograph by Michael P. Smith, courtesy of Elisabeth Laughlin, © The Historic New Orleans Collection. Pp. 70–71 photographs by Ray K. Metzker, courtesy of the artist. Pp. 72–75 photographs by Helen Levitt, courtesy of the artist.

BURDEN GALLERY

EXHIBITIONS
FALL 1985

ROBERT ADAMS/SUMMER NIGHTS

SEPTEMBER 10 TO OCTOBER 12, 1985

Robert Adams book *Summer Nights* is published
in conjunction with the Burden Gallery exhibition.

————————————

WILLIAM CHRISTENBERRY/WILLIAM EGGLESTON

OCTOBER 12 TO NOVEMBER 22, 1985

————————————

ROBERT GLENN KETCHUM

DECEMBER 10 TO FEBRUARY 1, 1986

SILVER MOUNTAIN FOUNDATION
INCLUDING APERTURE/BURDEN GALLERY/PAUL STRAND ARCHIVE
20 EAST 23 STREET, NEW YORK, NEW YORK (212) 475-8790

PAUL STRAND

WALL STREET, NEW YORK, 1915

"A workaday morning sight in the financial district of New York City became an unforgettable icon because Paul Strand's camera was a magic box that could transmute a moment of eternity into an eternal work of art."

MILTON W. BROWN, 1983, Distinguished American Art Historian and author of *American Art to 1900*

APERTURE ANNOUNCES AN EXCLUSIVE OPPORTUNITY for its subscribers: the single-print edition of Paul Strand's renowned photograph of Wall Street in 1915. This limited-edition photograph in platinum was printed at Paul Strand's direction from his original negative by Richard Benson in 1976 and 1977. As Milton W. Brown has written, "*Wall Street* remains one of Paul Strand's greatest and historically most significant photographs. It was one of seventeen photographs by Strand published by Alfred Stieglitz in *Camera Work* in 1916-17. These images struck the art world with stunning impact, establishing Strand as the most important and innovative new talent of the time."

"*Wall Street* has diminished neither in its relevance nor in its truth and beauty. Its imaginative conception, impeccable formal balance, and technical brilliance are as immediate and compelling as they were more than half a century ago."

Master printer Richard Benson worked closely with Paul Strand during the last five years of the artist's life, preparing the master prints for four single-print editions, all of which have now been produced in the rare platinum and palladium processes.

Each print is encased in its own handcrafted portfolio. The print is matted in four-ply museum quality mat board. An introductory essay by Milton W. Brown accompanies the print. The edition is limited to 100 numbered examples and ten artist's proofs.

This edition of *Wall Street* represents the only print of this image which will be offered for sale at any time.

Aperture subscribers are invited to purchase the single-print edition of *Wall Street* at the special price of $1250 before December 31, 1985. Any remaining prints will be offered to the general public for the price of $1800. Limited edition prints may be viewed by contacting Charles Stainback, Director of the Burden Gallery, at 212/505-5555.

Platinum/Palladium. 10⅛ x 12¹¹⁄₁₆ inches, matted to 18 x 22 inches

Silver Mountain Foundation, Inc., 20 E. 23 St., N.Y., N.Y. 10010

LET TRUTH BE THE PREJUDICE

W. EUGENE SMITH
HIS LIFE AND PHOTOGRAPHS

LET TRUTH BE THE PREJUDICE

W. EUGENE SMITH: HIS PHOTOGRAPHS & WRITINGS

"My station in life is to capture the action of life of the world, its humor, its tragedies, in other words, life as it is. A true picture, unposed and real."
—W. Eugene Smith

Moral passion and photographic truth were inseparable to W. Eugene Smith. He pursued both and the measure of his greatness is that he compromised neither. After more than 40 years of research and development, Aperture presents the definitive volume on W. Eugene Smith, one of photography's most important figures. This long-awaited collection includes over 200 of Smith's most powerful images, along with the first extensive biography of the photographic genius, written by the award-winning author of *Edward Weston: 50 Years*—Ben Maddow. Here are the major *Life* photo-essays, the portrait work and the great photo-epics of Smith's late period. Two classic photo-essays, "Man of Mercy" and "Spanish Village" have been expanded to show the full range of Smith's achievement in Africa with Albert Schweitzer and in Spain. Also included is Smith's masterful work in Haiti, never before seen in book form. This volume spans Smith's brilliant career from his days aboard an aircraft carrier, through the breadth of Pittsburgh, to the human suffering explicit in his last great essay made in Minamata.

Smith's achievements were realized at no small cost to himself and those around him. In the accompanying biography, "The Wounded Angel," Ben Maddow takes the measure of the man and looks unflinchingly at the muses and demons that drove W. Eugene Smith to the fulfillment of his dream of greatness.

The publication includes 250 photographs in facsimile reproduction, 192 pages, 10 x 12, and is available from Aperture or your bookseller at $50.00. Subscribers discount is 10%. It accompanies the major exhibition, *W. Eugene Smith: Let Truth Be the Prejudice*, organized by the Alfred Stieglitz Center of the Philadelphia Museum of Art.

Current Exhibition Schedule:

PHILADELPHIA MUSEUM OF ART
Philadelphia, Pennsylvania October 19, 1985–January 5, 1986
INTERNATIONAL CENTER OF PHOTOGRAPHY
New York, New York March 21–April 27, 1986
MUSEUM OF CONTEMPORARY ART
Los Angeles, California June 8–August 10, 1986
AMON CARTER MUSEUM
Forth Worth, Texas January 10–March 1, 1987
HIGH MUSEUM OF ART
Atlanta, Georgia June 2–August 23, 1987
MINNEAPOLIS INSTITUTE OF ARTS
Minneapolis, Minnesota September 12–November 8, 1987
THE CLEVELAND MUSEUM OF ART
Cleveland, Ohio December 2, 1987–January 24, 1988
GLENBOW MUSEUM
Calgary, Alberta, Canada August 27–October 23, 1988
INDIANAPOLIS MUSEUM OF ART
Indianapolis, Indiana December 3, 1988–January 29, 1989
CENTER FOR CREATIVE PHOTOGRAPHY
Tucson, Arizona February 25–April 23, 1989

SPECIAL OFFER FROM APERTURE

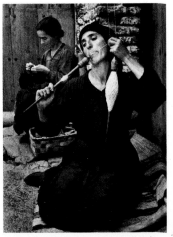

A facsimile hand-pulled gravure of one of Smith's greatest achievements, *The Spinner*, 1950 (image 9x12 in.). Each gravure has been approved by John Morris on behalf of the Estate of W. Eugene Smith and signed on the cover sheet.

Retail price: $175.00

For Aperture subscribers only, through June, 1986: $125.00